THE HARTFORD CIRCUS FIRE

THE HARTFORD CIRCUS FIRE

TRAGEDY UNDER THE BIG TOP

MICHAEL SKIDGELL

Charleston London

THE
History
PRESS

Published by The History Press
Charleston, SC 29403
www.historypress.net

First published 2014

Manufactured in the United States

ISBN 978.1.62619.069.6

Library of Congress CIP data applied for.

CONTENTS

ACKNOWLEDGEMENTS

It was a typical hot July day in 2001. I had just picked up my son from a sleepover at his friend's house on Church Street in Plainville, and I was taking the boys to my mom's house to swim in her pool. As the kids swam, I spent the day in my mother's basement going through some things that belonged to my father, who had died about six months earlier. Mixed in with my dad's things were some old newspapers, the *Hartford Courant* and the *Hartford Times*, from the day he was born, July 8, 1944, just two days after the Hartford circus fire. Of course, many of the stories in these newspapers were about the fire and the victims, and I read every word of these old stories, enthralled by them all. One surprising coincidence for me that day was that while reading Miss Ann Berube's obituary, I discovered that she had lived in the very same house where my son had just spent the night. I had even been given a tour of the house, which the family was renovating, the night before. That was the day that the Hartford circus fire drew me in and captivated me; the more I read about the fire, the more I wanted to learn.

I would like to dedicate this book to my father, Robert B. Skidgell, born in Hartford Hospital two days after the fire and taken from us many years too soon in 2001; I am sure he would have been proud to see this book. I would like to thank my mother, my sister and my son, Alex, for lending me their untiring ears during my years of researching the Hartford circus fire. Whether they genuinely enjoyed hearing me share new bits of information or they were just too kind to tell me otherwise, I love them all dearly.

I would also like to thank the numerous people with whom I have corresponded over the years that I've been studying the circus fire, particularly those whose families were forever affected by the tragedy. Some of those people include Laura Winzler Aldrich, James Bushnell and Mary Wallace Bushnell, Laura Hager DePuy, Donald Derby, Rosie Franz Geer, Edmund Hall Hindle, Diane Jacques, Lisa Kalish, Judy Roberts May, Carol Snelgrove McOmber, Janet Moore Sapolis, Charlotte Roberts Savino, Dennis Sullivan, Arthur Surdam, Steve Toth, Stephanie Logan Trombley, David de la Vergne, Tom de la Vergne, Jevan Walker, Linda Walkins and Charles R. Wallace.

Chapter 1
A TICKET TO TRAGEDY

Someone went to an usher and explained my mother's fear of heights, and he came up and took her to another seat. When she got to the seat she stood and waved to us. After the fire started, my father slid down the ropes, and Jack's father dropped us into his arms; then he slid down the rope.
Our fathers identified my mother at the Armory, by her wedding ring, and returned home late in the night.
DAVID DE LA VERGNE

The matinee performance of the Ringling Brothers and Barnum & Bailey ("Ringling") show at Hartford's Barbour Street circus grounds on July 6, 1944, was well attended. Patrons entered the grounds from Barbour Street, walking from their homes nearby or riding the city bus. Those who had saved up enough ration tickets to purchase the gasoline required for the trip drove to the site and found parking available on the lawns of local residents, a convenient way for homeowners to make a few dollars and help ease their displeasure from the commotion caused by the circus invading their neighborhood. From the street entrance, children and adults alike were tempted by a variety of concessions offered by circus vendors and sideshow attractions, including the living skeleton, the sword swallower, jugglers, the tattooed strong man and the world's smallest people, in the midway area. Past the sideshow was the animal menagerie, where elephants, giraffes and other corralled animals were available for everyone to see up close. White canvas walls, fifteen feet tall and attached to wagons, led the way through it

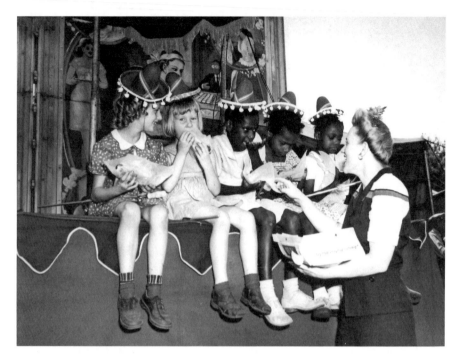

Children enjoy some food in the sideshow area before the fire at the Ringling Brothers and Barnum & Bailey circus performance in Hartford, Connecticut, on July 6, 1944. *Photo courtesy of Connecticut State Library, State Police Investigation Files, RG 161.*

all to the main entrance of the big top, with banners posted along the path illustrating the most exotic attractions that the circus had to offer.

Topless enclosures for the men's and women's toilets—in yellow canvas to distinguish them from the white sidewalls of the main tent—were installed close to the big top, men's to the right of the main entrance and women's to the left. No attendants were on duty at the toilet facilities, but Ringling employees checked on them periodically during the show. Between the toilet enclosures stood a grand canvas canopy marking the main entrance to the "Greatest Show on Earth." Before entering the big top, patrons would be required to visit the ticket wagons outside to purchase general admission tickets, pay the taxes due for free tickets or upgrade their tickets to the $1.20 reserved seats (tickets could also be upgraded inside). Vouchers for free tickets were handed out to area youths who helped during set-up and purchasers of U.S. war bonds, while handfuls of complimentary passes had been left with shop owners around the city several days earlier in exchange for displaying posters promoting the circus in their stores.

Ringling's big top was 200 feet wide by 450 feet long, with sidewalls that were 15 feet high. The waterproofed snow-white canvas roof of the big top sloped upward from the tops of the sidewalls to a towering 48 feet, the peak of which was topped with an American flag. The tent was erected over freshly mowed grass, dry from the summer heat, and dirt that had to be watered down and covered with hay and wood shavings to control the dust. Inside the massive tent, three rings and two stages were in place for the performers to show their talents, with a 25-foot-wide oval "Hippodrome track" separating the performance area from the spectators' seats. Patrons were allowed on the Hippodrome track up until the show began, at which time the ushers stationed around the tent would see that the spectators remained behind the railings in the seating areas. General admission bleacher seats, painted blue, were available at the east and west ends of the big top and were separated by an exit. The four sections of bleacher seats, enough for about 3,400 spectators, offered a spectacular view of one performance ring, but the other stages and rings were obstructed from view for those sitting in these seats. About 6,000 reserved seats, consisting of unsecured wooden folding chairs, painted red, were provided along the north and south sides of the big top and were divided into ten sections, providing a better view of all rings and stages. Exiting the tent could be done via the main entrance or by eight other smaller exits located around the big top. Many of these alternative exits, however, were used primarily by the performers and were blocked on the outside by circus wagons; patrons were encouraged to use other exits during the show. Nearly 7,000 spectators would fill the seats in the big top for the matinee show.

The weather in Hartford on the afternoon of July 6, 1944, was sunny and hot, eighty-eight degrees. The cloudy skies from earlier in the day had cleared for a few hours after noon, and the relative humidity was a comfortable 41 percent. The grounds had dried since being watered down that morning by Ringling's front-end man, but time restraints prevented him from watering them before the afternoon show. Inside the big top, conditions were sweltering. Even clad in light summer clothing, the spectators were hot and uncomfortable. Some sections of the canvas sidewall of the big top were lowered by a couple of feet to welcome the ten-mile-per-hour northerly breeze into the tent, providing random moments of relief to those inside. Mothers, children and grandparents composed the majority of the crowd, while many of Connecticut's able-bodied men were either in the service overseas or working in one of the many war plants in the Hartford area.

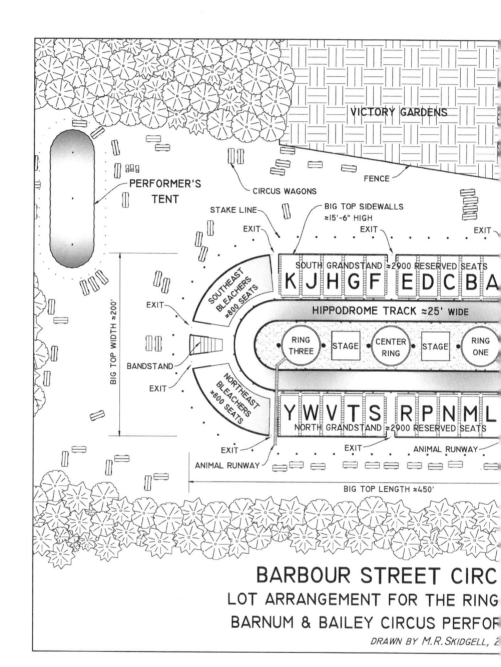

VICTORY GARDENS

FENCE

PERFORMER'S TENT

CIRCUS WAGONS

STAKE LINE

BIG TOP SIDEWALLS ≈15'-6" HIGH

EXIT EXIT EXIT

SOUTH GRANDSTAND ≈2900 RESERVED SEATS

K J H G F E D C B A

SOUTHEAST BLEACHERS ≈800 SEATS

HIPPODROME TRACK ≈25' WIDE

BIG TOP WIDTH ≈200'

EXIT

BANDSTAND

EXIT

RING THREE STAGE CENTER RING STAGE RING ONE

NORTHEAST BLEACHERS ≈800 SEATS

Y W V T S R P N M L

NORTH GRANDSTAND ≈2900 RESERVED SEATS

EXIT EXIT ANIMAL RUNWAY

ANIMAL RUNWAY

BIG TOP LENGTH ≈450'

BARBOUR STREET CIRC

LOT ARRANGEMENT FOR THE RING

BARNUM & BAILEY CIRCUS PERFOR

DRAWN BY M.R. SKIDGELL, 2

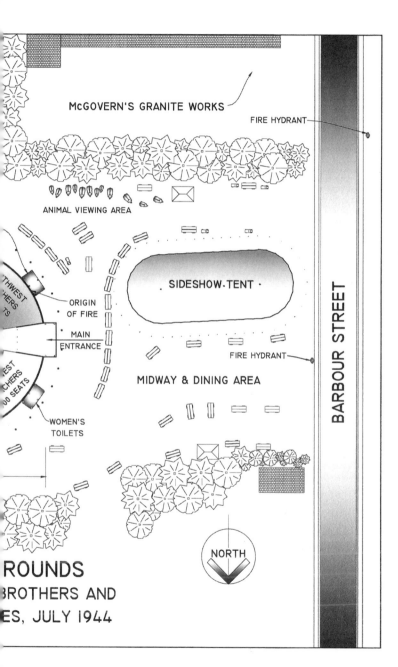

McGOVERN'S GRANITE WORKS

FIRE HYDRANT

ANIMAL VIEWING AREA

SIDESHOW·TENT

THWEST
HERS
TS

ORIGIN
OF FIRE

MAIN
ENTRANCE

FIRE HYDRANT

EST
HERS
00 SEATS

MIDWAY & DINING AREA

WOMEN'S
TOILETS

BARBOUR STREET

NORTH

ROUNDS

BROTHERS AND

ES, JULY 1944

Seating plan and lot arrangement for the July 6, 1944 performance of the Ringling Brothers and Barnum & Bailey Circus at the Barbour Street circus grounds in Hartford, Connecticut. *Drawing by author.*

Among the thousands to enter the big top at the main entrance were four teenaged girls who went to the first seating area to the right—the southwest bleachers. The girls went to the top row of the blue bleacher seats and sat about two board lengths from the neighboring reserved seating Section A. From their seats in the nearly full bleachers, they could look out behind them to the west through the opening where the sidewall canvas was lowered and see the animal handlers with the elephants and camels just outside the condensed menagerie area. The Barbour Street lot wasn't large enough for the full menagerie top that Ringling used at most sites, so just the sidewalls were erected around the animal cages and wagons.

The Big Show matinee on July 6, 1944, began just a few minutes after its scheduled 2:15 p.m. start time. Merle Evans's Big Show Band at the far end of the big top, opposite the main entrance, struck up "The Star-Spangled Banner." Ringmaster Fred Bradna and a parade of horses, elephants and performers welcomed the patriotic crowd, who were excited about a rare opportunity to witness an event as spectacular as Ringling's three-ring circus. Luxuries such as this were rare while World War II activity raged on overseas, and the war effort took priority for many of the country's manufactured goods and services. Hartford was busy doing its part for the war effort, with local businesses such as Colt's Firearms, the Royal Underwood Typewriter Company, Fuller Brush, Pratt and Whitney, Hamilton Standard and Sikorsky employing as many capable people as they could find and adding shifts to keep up with the government's demands for their products.

As the parade concluded, Ringling's prop men installed lengths of steel cage runways that connected to the animal cages in the first and third performance rings. The runways, about four feet tall and three feet wide, were installed directly on top of the Hippodrome track and passed through two of the big top's four exits on the long north side of the tent, leaving room for only a single file line of people to enter or exit at one time. On the outside, these runways connected to the animal wagons parked close to the north sidewall. Access around the Hippodrome track was extremely limited when these runways were in place, and the prop men would immediately remove them as soon as the last of Alfred Court's trained animals were herded back out to their cages on the wagons. Two sets of four-foot-wide wooden steps were installed over the steel animal runways to allow patrons, many just arriving, to pass over to get to their seats. Each runway had a telescoping section that was designed to allow it to easily slide over the next section, creating an opening for guests of the circus to pass though without the need for steps. Court did not favor this feature of the runway and felt that it was

A circus attendant helps a child and her mother use the steps to get over the animal runway before the July 6, 1944 performance in Hartford, Connecticut. The animal runways would become a fatal obstacle for many people trying to escape from the burning big top. *Photo by Carl Wallis, courtesy of Connecticut State Library, State Police Investigation Files, RG161.*

Interior view of the big top shortly before the fire started in Hartford on July 6, 1944. The wild animal act performing here had just finished when the fire was first noticed. *Photo by Carl Wallis, courtesy of Connecticut State Library, State Police Investigation Files, RG161.*

not safe as far as animal escapes were concerned, so the telescoping sections were secured with rope to prevent accidental opening.

The opening act of the show featured a twist on traditional lion tamer acts: dozens of showgirls in bright yellow military costumes being trained by performers in lion costumes with whips. This act segued into master animal trainer Alfred Court's exotic animals performing in rings one and three. Court was contracted by Ringling to provide the animals, trainers, cages, runways and other equipment, and Ringling's prop men were responsible for the installation and removal of the cages and runways before and after the act. Court himself was in New York City on the day of the fire while his trainers, in orange and black costumes, were performing with the animals. In ring three, at the far end opposite the main entrance, Joseph Walsh showed trained lions, polar bears and Great Danes while May Kovar commanded a collection of panthers, leopards and pumas in ring one, in front of the main entrance of the big top. Due to war-related labor shortages, Alfred Court's act had been reduced to two rings rather than three, and trainer Wilson Storey helped manage the big cats in ring one with Kovar. As the animal acts concluded simultaneously, the trainers began to usher their animals out of the exhibition rings.

As the animals were leaving the performance area, high-wire performers the Flying Wallendas took their positions on platforms thirty feet above the ground. On one platform stood Karl Wallenda, and opposite him on the platform in the north section of the big top were Karl's wife, Helen; his older brother, Herman; family friend and performer Joe Geiger; and Helen's sister, Henrietta. The Wallenda troupe took its position, and while waiting for Merle Evans to cue their music, the family of aerialists heard screams and saw the fire behind the southwest bleachers. They held their positions on the rigging, expecting the circus's seat men to extinguish the fire quickly so they could proceed with their act, which was expected to conclude with a death-defying bicycle-and-chair balancing routine on the high wire.

Two of the eight seat men in the big top for the July 6 matinee show were detailed by Ringling's boss canvas man Leonard Aylesworth to the west end bleachers, the two large sections of general admission seats to the immediate left and right of the main entrance. The seat men would typically take turns, alternating back and forth between their bleacher sections separated by the main entrance. They would help install the seats and supports when the show set up, which gave them a good knowledge of the system so they could spot a support jack that was out of place. Working his first season with the circus, seat man John "Cookie" Cook sat

underneath the southwest bleacher seats until about 2:15 p.m. and then left the area and went to the northwest bleachers, checking the jacks along his way to the animal runway at the northwest exit. Cook's fellow seat man under the west end bleachers, William "Red" Caley, a muscular former coal miner, left his post under the southwest bleachers a few minutes later and joined Cook at the northwest animal runway. Part of their job as seat men was to watch the seating support jacks when the prop men broke down and removed the steel animal runway that was next to the bleacher section they patrolled, and Caley thought that Cook might be too inexperienced to handle the task. One false move by the men removing the runways and a displaced jack could violently upset the patrons seated above. Caley advised him to go back to the southwest bleachers, but Cook stayed to assist with watching when the runways were removed.

At about 2:40 p.m., Ringling usher Kenneth "Shiek" Gwinnell first noticed the fire to his right as he was facing the reserved seats on the south side of the big top. The fire was about five feet off the ground on the canvas sidewall of the big top and behind the middle of the bleachers full of seated patrons. The ground was not on fire, just a patch of the sidewall at this time. He ran to fellow usher Mike "Dare" D'addario, who was on the track in front of his section, the southwest bleachers. When D'addario heard Gwinnell holler to him, he saw the fire climbing the sidewall behind his section, and the two ran under the bleachers and were joined by usher Louis Runyan, who had been stationed at the northwest bleachers. The three ushers each grabbed one of the four-gallon buckets of water under the seats, marked "For Fire Only," and D'addario tossed the water onto the burning sidewall canvas. Runyan tried to pull the sidewall down, but it was installed tightly to the roof canvas in this location, with the open-top men's toilet enclosure directly on the other side of this sidewall. By this time, the fire was ten feet up the sidewall, and in the seconds it took Gwinnell to get a fourth bucket of water, the flames reached the canvas roof of the tent and began to spread. The firefighting ushers realized that this fire was not going to be stopped with the equipment at hand, and they immediately resorted to getting the patrons out of the big top.

As the animal act in the first ring finished, May Kovar ushered her big cats into the runway. Seat men Caley and Cook, under the northwest bleachers watching the animals go through the runway, heard screams and what sounded like a stampede above them. Thinking an animal had gotten loose, they went out into the arena and saw the fire on the roof of the big top, right above the other section of bleachers that they were responsible for watching.

No one else was assigned to be or allowed under the seats, employee or patron, so it was their responsibility as seat men to patrol their areas and return any dropped items to the patrons above—and especially to watch for dropped cigarettes and any potential fire hazards. The red-and-silver water buckets under the seats were their essential tools and would often be used to extinguish small flare-ups before they got out of control. All circus workers knew to keep the buckets full and to immediately refill them if they were used. In case of a fire they couldn't extinguish with just the water buckets, the seat men were told to use a knife to cut the ropes loose and pull the sidewall canvas down to keep the roof canvas from catching.

The girls in the top row of the southwest bleachers began to feel extra hot as they watched May Kovar's act conclude. They turned and saw the sidewall canvas behind them on fire, and to their left, they saw the top of the tent burning just a few feet away. Others around them in the bleachers began to notice the growing patches of flames, and hollering ensued. While some spectators chose to remain seated, the girls walked down the bleacher seats and headed toward the main entrance, where they found themselves in a large crowd of people pushing and screaming. They saw small children overcome by the crowd and lose their footing, falling under the mass of patrons moving toward the exit as a single unit. When the girls got outside, they looked back and saw the American flag start to burn.

While the Hartford Fire Department had no official representation or coverage at the circus grounds during the circus's scheduled two-day stay on Barbour Street, Hartford Police Department's coverage was a matter of discussion on July 5, when Ringling's chief of police John Brice called on police headquarters. The circus relied on the protection of local police, since Brice was not only Ringling's police chief but also the sole member of its police department, aside from four "old-timers" whom the circus kept around as watchmen under Brice's direction. The number of men provided was left to be determined by Hartford Police chief Charles Hallissey, and before the matinee performance on July 6, the two chiefs met outside the main entrance to the Big Show and discussed where Brice would like the police coverage. His main priority was that Hallissey station a couple of men in the rear lot behind the big top around the performers' tent, to protect them from miscreants, and to this request the Hartford Police chief obliged, providing ten uniformed officers on the grounds and neighboring streets at no charge to the circus; they were considered city employees doing their job. In addition to these ten men, three Vice Division officers and three detectives were detailed to the grounds, all in plain clothes; and Chief

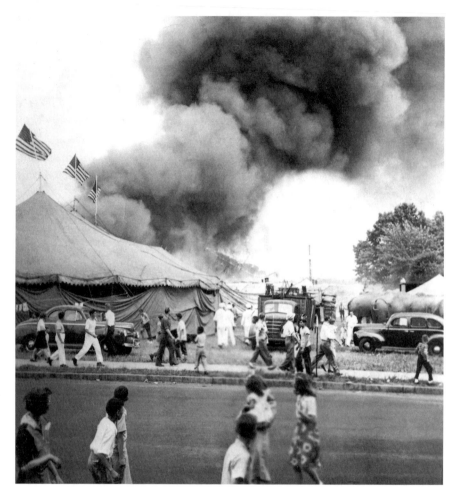

View from Barbour Street of the burning big top, which can be seen beyond the sideshow tent on the left. Handlers rushed the elephants, on the right, out of the area quickly to prevent even more chaos. *Photo by Ralph Emerson Sr., from author's collection.*

Hallissey, Assistant Chief Thomas F. Sullivan and the patrolman who drove them to the circus were on duty and on scene.

The Wallendas saw the fire on the sidewall rise and ignite the fringe on the edge of the waterproof canvas roof, and the flames began to spread upward quickly. Karl motioned across the tent for the others in his crew to get down, and he followed them down the rope ladder and out the rear exit. May Kovar, who would be killed by one of her lions five years later, noticed a sheet of flame while she was in the first performance ring sending the big

cats through the northwest runway and tried to rush the animals out. She struggled with a terrified beast that tried to run back into the ring as the fire spread above them and also had to separate a couple of big cats that started to fight inside the runway as patrons climbed over in their effort to escape. At the other end of the big top, Joseph Walsh had six lions in ring three when he noticed the fire and quickly rushed them out to their cages through the northeast runway, where many of the dead would soon be found.

Hartford Police officers James Kenefick and Henry Griffin were detailed to the back lot area of the circus grounds, at the east end of the big top and around the performers' dressing tent that was erected in the back corner of the lot. Officer J.F. Healy, scheduled to go on duty at three o'clock, had just seated his wife and child in Section V and was also at the east end, standing next to the bandstand and watching the show. Griffin was stepping in and out of the east entrance at the opposite end from the main entrance, keeping an alternating watch on the dressing tent and the bleacher seating areas at that end of the tent. Kenefick was standing in the exit between the southeast bleachers and the reserved seats when he noticed a commotion at the far end of the tent: people leaving their seats and a narrow flame working its way up the sidewall behind the bleachers. Griffin heard the commotion from outside and rushed inside to see the spectators heading toward him for the exit. Kenefick and Griffin kept them calm and moving, as the flames had now reached the roof canvas and were spreading quickly.

Hartford Police officer Joseph Weidel was also at the east end, waiting with Officer Healy to go on duty at three o'clock, when he noticed the fire and immediately ran toward it; his sons were seated in Section E, about halfway between his location and the fire, and he wanted to make sure they got out safely. Weidel found his boys, led them out and then returned to the east end to help, but the heat was too intense for him to enter. Officer George Sanford, off duty, was also at the east end with Weidel and Healy, wielding an 8mm movie camera to film the performing animals.

After the show began, Ringling general manager George W. Smith left the big top via the main entrance to check on things at the ticket wagon. He returned a few minutes later, saw the animals coming out of the runway and then noticed people crawling out from under the sidewall and thought perhaps an animal was loose. Smith hurried toward the main entrance and saw the canvas roof above the entrance in flames and the nearby elephants roaring and starting to stampede. He gathered the elephant handlers and instructed them to lead the massive animals toward Barbour Street, away from the fire, before they became uncontrollable. Although Smith was on

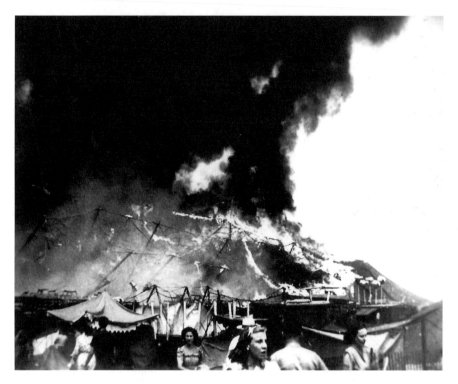

In this image, the paraffin-coated big top canvas has been almost completely consumed by fire. The remaining ropes are about to burn, and the support poles will fall to the ground, crushing everything in their path. *Photo by Spencer Torrell, from author's collection.*

leave from the circus during the 1942 Cleveland fire, he knew that panicked beasts would only make the current situation worse.

Hartford Police Department's traffic patrolmen were keeping Barbour Street clear in front of the circus grounds and helping people cross. Patrolman Anton Holst, standing across the street, looked over and saw fire at the southwest corner of the big top, above the men's toilet enclosure. Holst ran into a house, grabbed the phone and was calling the fire department when Sergeant Spellman arrived and completed the call. Spellman had just left the company of Chief Hallissey at the main entrance to the big top and was about fifty feet outside when he noticed the flash of flame on the roof of the tent. Knowing there were no telephones on the grounds, he ran to the white house across Barbour Street to call in the emergency.

Chief Hallissey and his assistant, Sullivan, arrived at the circus grounds about 2:30 p.m., driven onto the grounds in a patrol car that stopped at a

circus wagon to the left of the main entrance. The Hartford Police Department chiefs entered the big top, went through the crowd-control gates and railings and stood just inside the entrance to the left, near a ticket exchange station. They stopped to discuss the police details with Ringling's police chief Brice and Hartford's Sergeant Francis Spellman, and then Spellman left the area to check on his men stationed on the grounds. Inside the main entrance, Sullivan heard cries of "Fire!" from the southwest bleacher section and turned to Brice and Hallissey, who had also heard the screams. They all saw the flame on the upper part of the sidewall behind the bleachers, not quite at the edge of the roof yet. Brice bolted out of the tent to alert the circus folks, while Sullivan told Hallissey he'd hurry to the cruiser on Barbour Street and call in an alarm. Sullivan ran into Spellman along the way, on the same mission, and advised him to proceed while the assistant chief went back into the main entrance area. In preparation for the crowd that would be rushing the main entrance at any moment, Sullivan and Hallissey helped the circus workers clear out the pipes, ropes and canvas that obstructed the path out of the tent. Circus men cut the ropes and lowered the sidewall canvas in an effort to keep the fire from spreading.

Connecticut's commissioner of state police Edward J. Hickey, who also held the position of state fire marshal, was in attendance at the circus, sitting in the top row of reserved seating Section G, to the right side of the big top when walking in the main entrance. Hickey heard the cries of "Fire!" after watching the animal act, and looking to his left, he saw the flames on the sidewall behind the southwest bleachers and observed for a minute, watching to see if circus employees would put the fire out. When the flames reached the edge of the roof canvas, the small fire increased in size and began to travel rapidly upward. A breeze fed the fire, and suddenly sheets of flame shot toward the northeast and northwest corners of the big top. Spectators began to panic at this point and scrambled to get out of the tent. Ushers waved their arms and tried to calm the crowd while leading them out quickly, and the band played on, masking the screams. Section G had cleared out before Hickey decided it was time to get his group out of the burning tent. Unsecured to the platforms, the red seats in his and the other reserved sections were in heaps and blocking the aisles down to the Hippodrome track. Commissioner Hickey walked along the top row of seats until he found a clear way to get down with the children from his group who hadn't already jumped from the top of the bleachers.

With the patrons leaving the southeast section of the tent without much difficulty, the attention of Officers Griffin and Kenefick was drawn across

the tent to the northeast section, where they noticed a huddle of people struggling to get over the steel animal runway that was blocking not only the Hippodrome track but also a good portion of the exit in that corner of the big top. The stairway over the runway was jammed, and people were trying to climb over the steel bars. As the flames overhead bore down on them, the officers began helping people over, tossing children and helping pry loose the feet that got stuck between the bars. While Officer Healy was trying to pull the runway sections apart, Griffin and Kenefick tried to help, but it was no use; they continued their efforts to pull people over the runway. Once the flames reached the center pole of the big top, the entire north section of roof seemed to explode at once, forcing the officers to flee the tent seconds before it collapsed on those who remained inside.

When Hartford's Chief Hallissey saw people were exiting the main entrance without problem, he left the area to find a telephone. He settled for the radio in a police cruiser that was parked on the site, and while speaking with police headquarters, Connecticut's commissioner of state police Edward J. Hickey approached, having just escaped the burning tent with his nieces and nephews. Hallissey gave his and the commissioner's orders to headquarters and returned to the circus grounds. By the time he arrived at the northeast corner, where one of the animal runways was located, there was a pile of burned bodies waiting for him. Hallissey had worked thirty-five years for the police department, and in just his third year as chief, he was looking forward to retirement. With police department reorganization planned by Mayor Mortensen, Hallissey would take a leave of absence in April 1945 until his retirement later that year in October at age sixty-five. Retirement was short for the former chief, as he died eight months afterward from a cerebral hemorrhage.

Just outside the big top, twenty-five feet from the south side of the tent behind seating Section A, were a few stake-and-chain wagons; outside one of them, Ringling's wagon caretaker was shaving when he heard hollering. There was nothing but one hundred feet of space and a few animal cages between him and the men's toilet enclosure at the southwest corner of the big top. He looked and saw the roof of the tent ablaze but the men's enclosure and sidewall intact. He ran over to the big top and began cutting sidewalls on the south side with his knife, making openings for people to escape. East of the stake-and-chain wagons were the two diesel engine wagons, the "light plants" and three electrical supply wagons, parked close to the center exit along the long south side of the tent, facing the neighborhood's victory gardens. Cables from the big top's main switchbox, located inside the tent

just east of the center performance ring, ran underground beneath the grandstand out to the light plants that powered all the lighting inside the big top. An additional diesel engine was located in the back lot by the performers' tent, and two more were out front between the main entrance and the sideshow top. When the fire was first noticed, one of the diesel mechanics shut the light plants off and pulled all the plugs, while the switchbox man immediately shut his switches off and went out to the Hippodrome track to help the ushers lead patrons out of the burning tent. After he escaped the fire and the big top had collapsed, the switchbox operator went to the light plants and used a fire extinguisher to put out the fire on the Electrical Department's wagons.

Edward "Whitey" Versteeg, Ringling's Electrical and Diesel Department superintendent, was in his office wagon, next to the light plants and electrical supply wagons on the south side of the big top. He couldn't see the men's toilet enclosure from his location but saw the fire on the roof of the top above where it would be. The big top sidewall near his wagons hadn't caught fire yet, and he ordered his crew to cut the ropes that attached the canopy over his wagons to the big top. He and two of his men grabbed fire extinguishers from one of his wagons as the tractor men were trying to pull them away from the fire, struggling with the task when the wagons collided and became stuck together. Versteeg used his fire extinguisher on his office wagon, which was burning as they moved it. Versteeg's second assistant, Jersey Foster, had been making his rounds—checking the cables and connections and walking from the light plants toward the main entrance of the big top—when he noticed the top of the tent on fire. He and others made chutes from the sliced sidewall canvas and urged spectators to jump and slide to safety from the top row of the south grandstand.

Ringling clown Emmett Kelly, starring in the show's "Panto's Paradise" production number featuring a hobo clown who falls asleep and has some exotic dreams, was in the performers' tent in the back lot applying his make-up during the animal acts. Kelly heard the cries of "Fire!" and looked outside; he saw fire coming from the front end of the show and thought at first it was in the sideshow area. When he saw the black smoke, he knew the top was on fire; he recognized the black smoke from when the circus's menagerie top had burned in Cleveland two years before. The sad-faced clown grabbed his bucket of washing water and ran out of the dressing tent toward the fire. Along the way, as he approached the light plant wagons, he joined the workers who were putting out the fire on the wagons, and a tractor came to move them away from the fire.

Hartford Police officers William Spillane and Mark Grady were detailed to the front yard of the circus grounds, keeping watch on the ticket and office wagons and the sideshow area. At the first cries of "Fire!" they turned to see a growing hole of flame in the big top above the men's toilet enclosure and people starting to rush out of the main entrance. Officer Grady found injured women Nellie Hart and Lillian Logan on the grounds and rushed them immediately to Municipal Hospital, where Mrs. Hart died from her injuries almost three weeks later; Mrs. Logan survived, though her daughter, Sandra, was trampled in the fire.

Hartford Police Department detective Thomas C. Barber, on duty at the circus in civilian clothes, arrived at the circus grounds about 1:30 p.m. and remained in the midway area until 2:15 p.m. He entered the main tent with Detectives Thomas Kershaw and Paul Beckwith, as well as Mr. Francis Cunningham, parole officer from Connecticut Reformatory in Cheshire, with whom the detectives had an appointment. Cunningham was watching for a parole violator who was believed to be part of the crew breaking down the animal act cages. The plan was for the men to split into pairs after the act, with two of them remaining at the main entrance to watch the workers at ring one while the other two watched the men breaking down ring three at the east end. The men were standing in the main entrance when the fire was noticed; as Barber watched the animals leave the ring and enter the runway, someone yelled, "Fire!" and he looked to his right and saw the flames above the heads of and behind people in the southwest bleachers. Barber, Kershaw, Cunningham and Beckwith helped keep people calm and orderly as they exited until the heat became unbearable and they had to retreat. It took less than four minutes for the entire big top to collapse from the time they first saw the fire.

Officer Beckwith stood to the right side in the main entrance and saw the fire before people began screaming. He silently watched the small flame move toward the roof of the tent for half a minute, hoping that it would be extinguished before the crowd noticed it and became excited. The flames began to climb rapidly; he heard the usher yell, "Fire!" and saw him point to the area as people began to file out.

Also just inside the main entrance to the big top were three plainclothes police officers from Hartford Police Department's Vice and Liquor Division, assigned to the circus by Chief Hallissey to watch for pick-pocketing and other crimes. They, too, saw the usher in front of them point and holler, "Fire!"; vice officers Charles Regan and Daniel McAuliffe looked to their right and saw a burst of fire as the flames on the sidewall ignited the roof

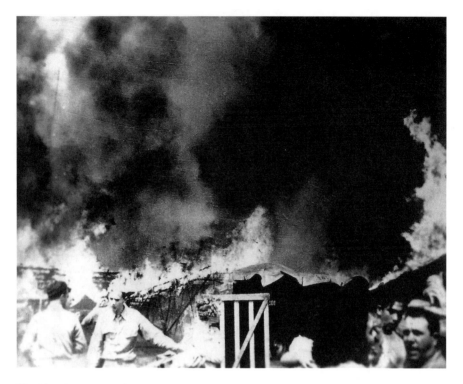

The bleachers and seating framework continued to burn as the fire spread after consuming the canvas of the big top. *Photo by Spencer Torrell, from author's collection.*

canvas above the heads of the people in the southwest bleachers, and they went into action helping people get out of the tent in an orderly manner. Some parents in the top rows of the bleachers dropped their children down to the officers and then jumped down after them. As Officer McAuliffe caught one boy, the child's father jumped down and said, "That dirty son-of-a-bitch threw a cigarette butt!" before disappearing into the crowd that was fleeing the burning tent. When Commissioner Hickey heard this during the officer's testimony later that evening, he directed Officer McAuliffe and the Hartford Police Department to find the man who made the statement and obtain more information about who tossed the cigarette. Attempts to find the man using the social media of 1944—newspaper and radio—were unsuccessful, and the lead went cold.

Five men from Hartford Police Department's Traffic Division had been detailed to the circus grounds and the surrounding area, led by Lieutenant George Dworak, who was down Barbour Street near Kensington Street

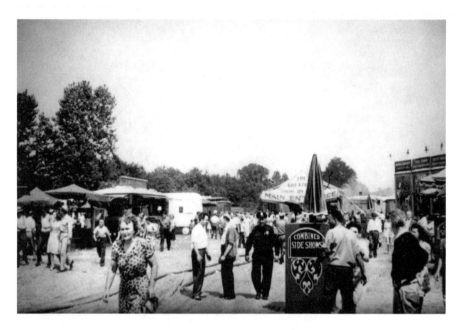

The midway area of the circus filled with people as the big top smoldered beyond, to the right. *Photo by Spencer Torrell, courtesy of Connecticut State Library, State Police Investigation Files, RG 161.*

taking care of traffic and helping people cross the street when he heard the fire trucks. He sprinted to the circus entrance and found the area congested. With Traffic Division sergeant Anthony Juliano, Dworak began moving the crowd out to Barbour Street. Leaving Sergeant Juliano, Lieutenant Dworak made his way to the rear of the big top, running along the north side of the ruins, and found an urgent need for ambulances at this location. He commandeered a circus bus, placed some injured women and children inside and gave the driver directions to Municipal Hospital. Two army trucks arrived to bring more injured people to the hospital, and five cars that had been parked nearby were volunteered by their owners.

Chapter 2

THE GREATEST SHOW ON EARTH

People started going down the bleachers throwing chairs left and right as they went. When I got my leg caught, someone fell on me and my mother turned around and pulled me to safety.
EDMUND HALL HINDLE

What began as a backyard circus in Wisconsin put on by five talented and enterprising brothers in 1882 quickly captured the approval of local audiences, and the young men took their Ringling Brothers Circus on the road in 1884. The circus grew substantially over the following years, and the Ringlings bought their competitor in 1907, the Barnum & Bailey Circus, and continued to run the shows independently until combining them in 1919, renaming the merged circuses the Ringling Brothers and Barnum & Bailey Combined Shows, Inc.

Born in 1869, Edith (Conway) "Mrs. Charlie" Ringling met her husband, Charles Ringling, one of the original brothers who founded the circus, as a teenager in Baraboo, Wisconsin. Edith became part of the little backyard show in the original days, and she and Charles were married in 1890. After a visit to the home of Charles's flamboyant younger brother John Ringling in 1912, the couple fell in love with the Sarasota, Florida area and began construction of a palatial million-dollar home there in 1925, with the mansion completed just before "Mr. Charlie's" death in 1926, one day after his sixty-third birthday. Edith inherited her husband's ownership in the circus and became a one-third owner of the Big Show. She was vice-

president of the Ringling show in 1944 and had a binding agreement with fellow vice-president Aubrey Haley that required the two women to vote together on issues in the boardroom.

Aubrey Barlow (Black) Haley, born in 1894 in Montana, entered the Ringling clan at age twenty-three with her marriage to Richard T. Ringling, son of one of the founding five brothers, Alfred T. Ringling. Richard suffered from heart disease and passed away in 1931 at age thirty-six on his forty-five-thousand-acre Montana ranch, where he and Aubrey ran a sheep and cattle business in addition to their duties with the circus. Aubrey, widowed with three children, inherited her husband's one-third ownership in the circus and married again two years after Richard's death, though this second marriage was short-lived. In 1942, she wed James Haley, the accountant for the estate of the last surviving founding brother, John Ringling.

John Ringling North and his mother, Ida, sister of the founding Ringling brothers, hired accountant James A. Haley to manage the estate of John Ringling, who died in 1936. Haley, born just before the turn of the century in Alabama, began working for the circus empire, in addition to his bookkeeping duties for the estate, by making regular visits to Ringling's winter quarters in Sarasota to check on things while the show was on the road, for a salary of twenty-five dollars a week. Haley moved into a vice-president position after John Ringling North and brother Henry took leaves of absence in 1943. James and his wife, Aubrey, each held vice-president positions with the circus in 1944, and James, the only director of the company on the grounds during the July 6 performance, was the highest Ringling employee to be sentenced for a role in the circus fire. After his release from prison, Haley became president of the circus, though his election to the position was later determined to be in violation of the women's voting agreement and was reversed by the Delaware Supreme Court. Haley and his wife soon sold their shares and got out of the circus business for good. James had his civil rights restored by the State of Florida in 1946, having lost them as a result of his conviction in the circus fire. He served two terms in the Florida state legislature and was elected in 1952 to represent Florida in Congress, where he served for twenty-four years until his retirement.

Prior to the 1943 season, Ringling's Board of Directors met to discuss keeping the show in winter quarters for the year, fearing that World War II–related manpower shortages and railroad limitations were too much for the circus to overcome. President of the show since 1938, John Ringling North and his brother, vice-president Henry Ringling North, sons of Ida (Ringling) North, vehemently opposed sending the show on the road. After a heated

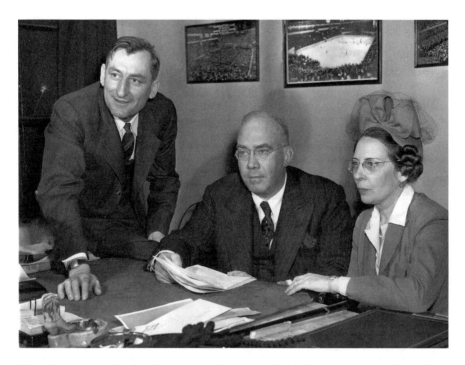

New officers of the Ringling Brothers and Barnum & Bailey Circus were elected in 1943: James Haley, first vice-president (left); Robert Ringling, president (center); and Aubrey Ringling, vice-president (right), wife of James Haley and widow of Richard T. Ringling. *Photo by Wide World Pictures, from author's collection.*

boardroom discussion, the two brothers agreed to take leaves of absence, with full pay, for the balances of their terms to disassociate themselves from sure disaster. Robert Ringling, son of Edith and her late husband, Charles, would take over as president, and with his vice-presidents, Aubrey Haley and Edith Ringling, the directors made cuts to the show to comply with the U.S. Office of Defense Transportation, which gave priority on America's rails to war-related production and transport. The menagerie top was pulled from the tour, and the show played fewer cities and longer engagements, with less manpower, and enjoyed a most profitable season.

The menagerie tent, having burned to the ground in 1942 and being retired for 1943, was back for the 1944 season, though the size of the Barbour Street grounds prevented the erection of the full menagerie top in Hartford. Fire ravaged Ringling's menagerie tent in Cleveland in August 1942, killing dozens of caged animals, including most of the show's camels, zebras, elephants, lions, tigers and giraffes. Patrons hadn't been allowed to

enter the grounds yet, and most of the crew was a few blocks away at the cook's tent having lunch when the menagerie tent caught fire around noon. The sidewalls and top canvas were consumed in less than fifteen minutes, unveiling cages of animals in various stages of despair, unable to escape the smoke and heat. Many of the suffering animals, including an elephant that required eight shots to end his life, had to be euthanized on scene by policemen using their service revolvers. Ringling's performing animals were unharmed, and injuries to workers were minimal; the afternoon performance was cancelled, but the lot was cleaned up just in time for the scheduled evening show to go on as planned. A sixteen-year-old roustabout with the circus, recently fired, confessed to setting a pile of hay on fire with a man who threatened to harm the boy if he didn't join him. Authorities were skeptical of the confession since the accomplice couldn't be identified, and the teen later recanted his initial confession, leaving the case cold.

The Cleveland fire, recent enough to be fresh in the memories of the traveling circus crew, had been the only serious big tent fire that Ringling experienced in recent years. In 1912, the Ringling Brothers show lost its big top in a fire just before opening the grounds for a performance in Sterling, Illinois. It was believed that embers from a nearby barn fire were carried by the wind and landed on the big top, setting it afire. Two years before the Sterling fire, in Schenectady, New York, the Barnum & Bailey show's big top had burned to the ground before a performance. Miraculously, all of the nearly twelve thousand spectators escaped without any serious injuries reported. The cause of the Schenectady fire was believed to be a carelessly discarded cigarette or match tossed from the bleachers. Seat men threw water on the fire to no avail and then tried to drop sections of sidewall to keep the fire from spreading, but once the flames reached the roof canvas, there was no stopping the consumption of the big top. And in 1916, a Ringling Brothers stock tent caught fire, killing dozens of horses and injuring dozens more that later had to be euthanized.

As the Ringling circus prepared for the upcoming season in its winter quarters, a new canvas was laid out on its lot in Sarasota on a sunny day in May 1944. Cotton-drill canvas was used for the sidewalls, which were not given any fire or water protection treatment. Small holes were sometimes found in the sidewall canvas, and the seat men occasionally saw the walls catch fire, typically easily extinguished with a pail of water. George Kelly, who had worked twenty years with the circus as a sail-maker, traveled with the show and made repairs to the big top and other canvas tents that Ringling used. The sidewall was new for the 1944 season, so he hadn't made

many repairs. There were some cuts that he had to fix just before setting up in Hartford. Twill canvas, with a stronger cross-weave pattern, was used for the big top roof, after being treated with water repellant.

Previously blue in color to darken the inside of the big top for the artificial lighting to be more effective, the new roof canvas was white to allow more natural light inside. Truck and tractor superintendent David Blanchfield was on hand with equipment and a crew to spread the canvas out and move it around as needed. The waterproofing process for the canvas roof required sixty barrels of yellow paraffin wax purchased from Standard Oil, three hundred pounds each, and six thousand gallons of gasoline. Boss canvas man Leonard Aylesworth directed a crew of seventy men to apply the mixture of four parts gasoline to one part melted wax—an age-old formula passed down to him by his predecessor—onto the new canvas roof with watering cans and spread it out evenly with large brooms. As the gasoline evaporates after a short period of time, it is not a factor in the flammability of the canvas. Once the canvas has been dragged through the dirt and exposed to the elements for a few days, all evidence of the gasoline dissipates. Only the roof canvas was given this treatment; penetration of rain through the sidewall canvas wasn't a big concern.

Ringling's big top canvas had never been given a fireproofing treatment. When he took over as president in 1943, Robert Ringling insisted on the circus using a fire-resistant canvas, regardless of cost, and samples of treatments said to be fireproof were tested. Hooper Manufacturing Company in Baltimore had a product that it claimed would fireproof the big top, but samples tested by Ringling were found to be flammable. Ringling's boss canvas man Aylesworth didn't feel the process impregnated the canvas enough to endure the beating that the circus's big top takes during a season.

George Washington Smith, general manager of the Ringling circus since 1938, was in charge of seeing that things got done on the circus grounds, hiring bosses, buying materials and overseeing routing and transportation. Smith, a circus veteran known for his skills in operating a big show, took leave from Ringling for the 1942 season when called to manage the U.S. Army War Show, an eighteen-city tour with a live show designed to inspire Americans to support their army. The show played to sold-out stadium crowds across the country, and when the tour was over, Smith returned to his role with Ringling as the man in charge of everything on the circus grounds.

After a couple of charity shows in Sarasota in March, Ringling's 1944 season began on April 5 with the first section of the show playing for two months at indoor arenas: New York City's Madison Square Garden and

George Washington Smith, shown here after being named general manager of the Ringling Brothers and Barnum & Bailey Circus in 1938 at age forty-three. Smith was one of five circus men held responsible for the fire by the State of Connecticut. *AP Wirephoto, from author's collection.*

Boston Garden in Massachusetts. New, stricter fire laws were in place for the indoor shows, particularly for the shows in Boston, where the Cocoanut Grove nightclub fire had claimed 492 lives less than two years earlier. Seating capacity was reduced in the arenas in favor of additional exits and safety measures. The circus's big top, the same one that would be destroyed in Hartford, and certain other equipment wasn't needed for these dates and joined the rest of the show in Philadelphia on June 5.

As Allied troops began the invasion of Normandy in France on June 6, 1944, D-day, Ringling opened the second portion of its season in Philadelphia, Pennsylvania, outdoors under the big top to a sold-out crowd. After two weeks of performances in Philadelphia, the show made its way to

New England with performances in Waterbury, New Haven and Bridgeport, Connecticut; Worcester and Fitchburg, Massachusetts; Manchester, New Hampshire; and Portland, Maine.

The circus would set up in Portland, Maine, for shows scheduled on June 30 and July 1. Extra help was easy to find in this city, and among the temporary workers whom Ringling had picked up on this visit to Maine were homeless "town clown" Roy Tuttle and fourteen-year-old runaway Robert Dale Segee. Both were later considered suspicious and investigated by police for their possible involvement in the Hartford circus fire. During one of the Portland performances, a spectator alerted an attendant to a small fire on the aerialist's rigging, and it was quickly extinguished.

Providence, Rhode Island, was host for the Big Show on the third and fourth of July 1944. Ringling had 587 employees for the July 4 show, which was short of the 800 required to move the show most efficiently. Manpower in Hartford was even fewer. Though the Providence Police Department confirmed that it received no reports of fires at the circus during the performances and Ringling's wagon man Joe Lloyd knew of no fires, seat man Neil Todd testified that he put out about a dozen fires on the sidewall canvas that season using pails of water, including one in Providence. After putting out a fire, he'd let the sail-maker know that a repair was needed, and it would be taken care of. Todd worked under the grandstand seats at each show, where the floor beneath the seats was solid and the only place for a cigarette to be dropped down below was at the top row of seats; he found several dropped cigarettes at every show. The bleacher seats were of different construction, consisting of planks for seats that were open to the space below, affording every seated patron an opportunity to drop a cigarette or match. Ringling prohibited its employees who worked around the public from smoking during performances, and all smoking was forbidden by order of boss canvas man Aylesworth when the big top was being erected and taken down. Historically, preventing patrons from smoking was a futile task without assistance from local authorities and was done by the circus only when requested. The No Smoking signs would be displayed in cities only when required by the fire officials, and Hartford made no such request in 1944 or any previous year. In fact, Hartford's fire officials made no requests of the circus at all.

Leaving Providence and headed for Hartford, the circus ran into unexpected rail delays and was late to its destination on July 5. Ringling was forced to cancel the Wednesday matinee show but planned to be ready for the evening show to go on as scheduled. All available hands were called

on for setting up the grounds, and local men and boys were lured to help in exchange for free passes or hot meals from the circus's cook tent, where over three thousand meals were served each day. When manpower in a town was short, such as in Hartford, with many of the local men serving in the war or working long, demanding shifts in one of the city's many war plants, performers even pitched in with setting up. And of course, Ringling's mighty elephants assisted, raising the heavy tent poles almost effortlessly.

Connecticut was a regular stop for traveling circuses dating back to the late nineteenth century, and Hartford in particular was a favored location. The Greatest Show on Earth had played in the state nearly every year since Ringling Brothers combined its show with the Barnum & Bailey show in 1919, skipping only 1926 and 1938, when the Big Show's season was cut short due to labor problems. Hartford welcomed the circus each time it visited the state, aside from 1942, when the show was limited by rail restrictions, with Colt Park hosting the show until the Barbour Street lot was secured as a replacement. Ringling would continue showing at the Barbour Street circus ground after the city purchased the nine-acre lot in 1928 with plans to build a high school on the site. The high school was never built on Barbour Street, but decades later, in 1962, the Fred D. Wish Elementary School was built and opened.

Ringling's Herbert DuVal, who had worked thirty-one years with the circus as the adjuster, was the man who took care of things like licenses, permits, taxes and other miscellaneous bills. He carried $1,000 cash with him for these expenses, replenished at the red office wagon when he turned in his receipts. As he did in each town where the circus was scheduled to play, Ringling's advance man W.J. Conway made arrangements in Hartford with the city clerk in February 1944, and he let DuVal know what licenses and fees were required. Upon the arrival of the circus in Hartford on the afternoon of July 5, DuVal paid a visit to the city clerk, as he had done in years past, and paid a total of $300 ($150 per day) for the license for exhibition on the circus lot, issued in police chief Hallissey's name. In the basement office at city hall, he then made total payment of $500 ($250 per day) to Hartford's superintendent of Public Buildings for rental of the Barbour Street grounds from the City of Hartford. On July 6, DuVal had received word from McGovern's Granite Works, located on the lot next to the circus lot, that the owner was displeased about the circus folks possibly damaging his property and was looking for reimbursement of $32 he had paid for added security. As he stepped out of his white office wagon for a meeting with McGovern's that would never happen, DuVal noticed flames leaping up from the area near the men's toilet enclosure, with the edge of the roof just catching fire.

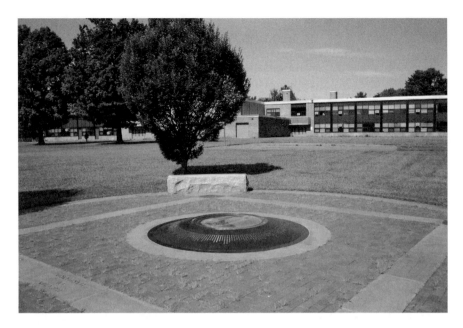

The Hartford Circus Fire Memorial, erected in 2004 on the grounds of the Fred D. Wish School at 350 Barbour Street in Hartford. The bronze medallion marks the location of the center ring of the big top on July 6, 1944. This 2013 view is looking toward the origin of the fire, behind the southwest bleachers. *Photo by author.*

The nine-acre Barbour Street circus grounds lot was prepared a day or two before the Big Show arrived in town. The central area of the lot, where the big top would be erected, was littered with debris, which the crew removed from the lot, and sparse grass. Fields of grass, two feet tall, along the north and south sides of the grounds were mowed, with some of the trimmings removed with the debris and some left behind for the circus to use as feed and bedding for the animals. The men also covered the sidewalk along Barbour Street, at the entrance to the circus grounds, with a thick padding of dirt for protection against the traffic of Ringling's heavy trucks and equipment. The lot was ready.

Chief usher John Carson, with his crew of ushers, spread the sidewall canvas out and put the side poles in place while waiting for others to erect the quarter poles and the canvas. His crew size during normal conditions was seventy-two, but he'd been working with around fifty men for some time. His ushers also erected the grandstand seating structures, and they put the red chairs in place. After a show, the ushers removed the chairs and swept the entire grandstand floor, and after the last performance,

they tore it all down and packed it up, including the sidewall canvas. Carson patrolled the grandstand areas to make sure his ushers did not overlap the seats, a common practice for a dishonest usher to make some extra money on the side by pocketing the money charged to a patron for an upgraded seat.

Ringling assistant boss canvas man John "Blinkie" Meck and his crew installed the sidewall of the big top, tying the canvas to the poles at the top and stretching it tight at the bottom. They dug a shallow trench at the base of the sidewall to catch any rainwater run-off so that the canvas sat in the trench with no bunching while the turned-up dirt formed a curb on the inner side of the sidewall. Between the tent poles, they lowered the top of the sidewall canvas for ventilation if it was needed. Before the July 6 show, Meck's crew had tied up the sidewall above both animal runway locations in advance to keep the canvas out of reach of the animals that would be passing through. Meck always walked around during the shows, checking on things, and was under the seats near the animal runway in the northwest corner of the big top when the fire broke out. He later testified that it had been a couple of years since he'd seen a sidewall on fire, though he knew that the seat men sometimes put out fires caused by cigarettes.

Fifty-seven-year-old David W. Blanchfield, Ringling's superintendent of the Trucks and Tractors Department, was born in and grew up in Hartford, though he hadn't lived there in the twenty-five years since becoming a circus man. He was in charge of a crew of about forty men, and since he needed hard-to-find experienced men who could operate trucks and heavy equipment, his crew had been short all season. His men hadn't been given any formal instructions on fighting fire; they just did what he told them to do when there was an emergency. Included in Blanchfield's fleet of trucks were the circus's four one-thousand-gallon water trucks, each with a two-man crew and one hundred feet of two-inch hose. They were not specifically for use in fighting fire but were regularly used to wet down the lot and deliver water for the animals and the cook's tent. The water trucks were each equipped with a pump powered by the truck's engine, capable of throwing a relatively narrow water stream about sixty feet. They were kept full of water from the fire hydrant on Cleveland Avenue; using the hydrant in front of the circus lot on Barbour Street would have created an unwelcoming muddy mess at the entrance. All four trucks were full when the fire began. Had one been located at the origin of the fire and responded before the flames reached the roof of the tent, disaster surely would have been averted.

Thirty-five-year veteran with the circus Joe Lloyd, Ringling's caretaker of the stake-and-chain wagons, installed the toilet enclosures with help from his small crew of men. They took one-hundred-foot lengths of untreated yellow sidewall canvas and formed a topless, four-sided box with a doorway around the wooden structure and oil drums that composed the toilets. They erected these enclosures close to the big top sidewall, with just an inch or two between, and the top of the toilet enclosure sidewall was lowered a bit, with the canvas bunched up at the bottom. A week after the fire, Lloyd revisited the fire site with Connecticut investigators and recovered a seventy-foot length of the yellow canvas from the men's toilet enclosure area. One-third of the piece had burned, the portion that was in direct contact with the big top sidewall, and the remains lay right where they fell. Investigators gathered this section of canvas and took it with them for analysis. While this rather large piece of canvas remained right where the fire originated, the wooden toilet structure and the oil drums were burned. No chemicals were used in the toilets aside from disinfectants and deodorizers, ruling out the possibility of the fire having been started from a chemical reaction in the toilet enclosure, though the men's enclosure was where the fire was believed to have started.

Edward "Whitey" Versteeg, forty-four years old and with the show for two years, was Ringling's superintendent of the Electrical and Diesel Department. Versteeg took some general wiring classes when he was seventeen and found steady work in Los Angeles at film studios—MGM, Hal Roach and others. Though most of his training was what he had "picked up" over the years, he managed to acquire electrical licenses in Rhode Island and California while working for a contractor, no exam required. He was in charge of thirty-two men, twenty short of what he felt he should have. Versteeg was also in charge of the show's fire extinguishers, nearly four dozen in all, and when advised by the general manager, a couple dozen of them would be placed under the seats and at the exits when local fire officials required it. Since the Hartford Fire Department hadn't inspected the grounds, it didn't have any requirements for the placement of fire extinguishers in the big top. Versteeg had them placed in various trucks, tents and wagons around the lot, in particularly useful locations during normal operations, but none was under the seats. The circus preferred not to risk the damage of the fire extinguishers by subjecting them to lot dust and breakage under the seats, particularly when seat men with water buckets were normally very effective.

The city-owned circus grounds were not considered a particular fire hazard, as there were no fire hydrants or fire alarm boxes on the site. The nearest alarm box to the entrance of the Barbour Street circus grounds was about six hundred feet away at the corner of Cleveland Avenue; the nearest hydrant was across the street from the entrance, about three hundred feet from where the big top would be erected. Since 1940, the lot had two or three brush fires that required the fire department's attention each year. It had not been the custom of the Hartford Fire Department, or Chief John C. King, to detail any firefighters or apparatus to the grounds during the circus's visits, and on July 5 and 6, 1944, the custom, or lack thereof, continued. Other Connecticut towns that frequently hosted circuses—Bridgeport, Waterbury and Hamden—did not detail firefighters or apparatus to circus performances either, but Bridgeport and Waterbury did perform their own unsolicited inspections before any performances.

Hartford building supervisor William Ennis sent one of his inspectors to the Barbour Street circus grounds in the afternoon on July 5, as the Ringling workers were hastily erecting the seating. The building inspector was satisfied with what he saw; the erection of the big top, the exits and the seats were all done as they had been done in years past. Building code regulations at the time lacked any provisions specifically for "circuses," but Hartford's Building Department customarily inspected the adequacy of the exits in the big top on July 5, and it issued a certificate of occupancy, free of charge, as it had done before. It wasn't until July 7, the day after the fire, that someone from the Building Department actually took measurements of the exit locations in the big top. Ringling's evening show went on as scheduled, with a full crowd and without incident. The Hartford Police officers who were detailed to the circus grounds for the July 5 performance reported no problems and observed no fire hazards. They presumably noticed the animal runways blocking the Hippodrome track during the animal act but did not recognize them as potential hazards.

Opposite, top: Circus fans visit with the elephants outside the main entrance to the big top before the fire on July 6, 1944, in Hartford. The house in the background was located at 353 Barbour Street. *Photo courtesy of Connecticut State Library, State Police Investigation Files, RG 161.*

Opposite, bottom: Nicholas Zaccaro and Leo Goodman stand at the edge of an animal act cage and survey the ruins of the circus grounds after the July 6, 1944 fire. *Hartford Courant photo, courtesy of Connecticut State Library, State Police Investigation Files, RG161.*

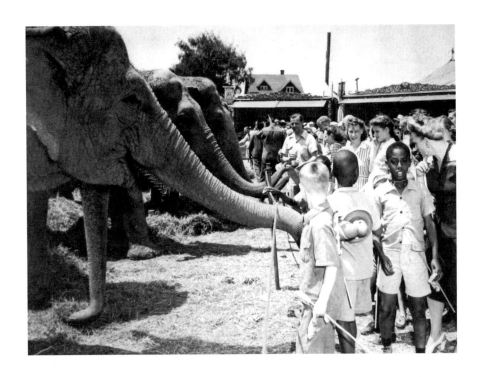

On the morning of July 6, several hours before the scheduled matinee show, Leonard Aylesworth left the Barbour Street circus grounds with a few men headed for the Big Show's next performance city, Springfield, Massachusetts. Fifty-two years old, married and a circus man since age twenty-two, Aylesworth had spent the last six seasons with Ringling as the boss canvas-man, and his wife traveled with him. He left the grounds at 9:00 a.m. on the day of the fire, letting General Manager Smith's assistant know of his plans in Springfield. Aylesworth's first assistant had taken leave from the show in Providence a few days earlier due to a death in the family, which left the circus's seat men without supervision. Aylesworth intended to be back before the first show but was delayed when the stake-driving truck they were waiting for got lost. After getting the men working on setting up the Springfield lot and driving stakes, he headed back to Hartford and noticed the smoke in the sky as he approached the city. Suspecting the worst, Aylesworth sped to the scene, but when he arrived at about three o'clock, the big top was nothing but smoldering ruins. He checked on his seat men upon his return to Hartford, and all of them were accounted for, although he observed that John Cook, one of the seat men assigned to be under the southwest bleachers, was very distraught and perspiring. Aylesworth went to get an officer to help the man, but when Aylesworth returned, Cook was gone.

Chapter 3

SOMEONE YELLED, "FIRE!"

At the stairs over the animal chute, in a crazed crowd, Dad slipped and fell with me. A man picked us both up and threw us over the chute to safety. As I hit the ground, I remember looking back and seeing a big flaming tent pole come crashing down not far from where we had just left.

DENNIS SULLIVAN

When he first became aware of the fire, Merle Evans directed his band at the far end of the big top to play "Stars and Stripes Forever," the circus's disaster march, which immediately signaled to all workers and performers within earshot that there was an emergency. The aerialists descended their positions from near the roof, and in the rings below, handlers continued to herd the big cats out through the runways that completely blocked the Hippodrome track in two places.

As the crowd of nearly seven thousand people began to notice the fire and the commotion it was causing in the southwest corner of the circus tent, they processed what they saw in different ways. Some thought the flames were part of the show; others assumed that circus personnel would extinguish them before they posed a threat. Most, however, began to rush toward the exits, particularly the one through which they had entered the big top just minutes earlier. Patrons in the lower levels of seats were able to quickly escape the tent before those in the higher seats descended. Those higher up in the reserved seat sections, the premium grandstand seats, knocked

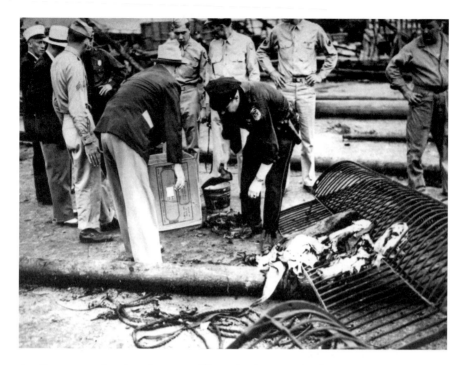

A policeman searches the ruins near a fallen animal runway for victims' belongings and evidence. Many of the victims were removed from this location. *Photo by Wesley Mason for the* Hartford Courant, *courtesy of Connecticut State Library, State Police Investigation Files, RG161.*

over their chairs in their hasty exit from the burning tent, creating deadly obstacles for anyone who tried to follow them. From the top rows of seats, about ten and a half feet off the ground, many chose to slide down the ropes behind them, risking rope burns, or jump down to the area behind the seats and escape under the canvas sidewall or through openings cut by patrons and circus workers. Less adept jumpers suffered injuries to their legs, feet, ankles and backs; one pregnant woman jumped and broke her pelvis, which led to a miscarriage.

Spectators in the bleacher sections, especially the ones at the end where the fire began, were provided the best opportunities to exit the tent. There were wide exits at each end of the big top next to each bleacher section, and the design of the bleacher seating, wooden planks with the spectator's feet dangling, allowed a person with even minimal skills to easily slide through to ground level. From the ground, people could escape under the sidewall or out of the end of the bleacher structure into an exit and out of the tent. At first, the people leaving didn't panic; only a few mothers and children

cried out for one another. Policemen and circus ushers were able to keep the crowd moving and calm until the flames on the big top roof began to spread rapidly toward the north and east.

As the fire consumed the tension ropes that held the tent poles in place, the poles ignited and began to fall, crushing any equipment or spectators in their path. With support poles falling one by one, the stretched canvas roof of the big top began to loosen, and as it did, the northerly breeze fanned the flames, chasing them toward the bandstand where Merle Evans's crew continued playing its disaster march. Burning sheets and strips of canvas coated with hot, melted wax fell from the roof above onto those trying to flee, adding to the panic of the crowd. When the center pole collapsed, the remains of the big top fell down in a blanket of flame on scores of people making their last desperate effort to escape the superheated arena. Many of those still inside had suffered debilitating injuries or were trapped by runways and fallen poles and could only watch in horror as the wax-coated, burning canvas enveloped them. Their collective final screams would blend with a chilling swishing sound as the air was pushed out of the tent by the falling big top, followed by a moment of stunned silence.

Ringling Trucks and Tractors Department superintendent David Blanchfield was in the backyard of the circus lot when he first heard the cries of "Fire!" and noticed a solid mass of flames coming from the southwest corner of the big top. He knew when he saw the roof burning that there would be no saving it. All they could hope to do was get the people out, protect the animals and keep the fire from spreading to other tents and wagons. Some equipment trucks that were backed up against the sidewall on the south side of the big top caught fire quickly, and Blanchfield had his men move these trucks out of the area as soon as he noticed they were burning. The water truck that he had stationed on the south side of the lot sprayed water on the wheels of the trucks, still burning after being pulled away from the blaze. Two other water trucks were sent to the north side of the tent to protect the animal wagons; if their cages burned and the animals got out, things would get even worse. En route to the animal wagons, Blanchfield was told that there were people burning in the northeast exit; he stopped the trucks and had them water down the people and bodies that had been trapped by the animal runway when the roof fell. As they sprayed the bodies, most with their clothes completely burned off, Blanchfield and his men searched the pile for signs of life. They pulled two women from the pile—one amazingly had just a small hole burned in her stocking.

State police commissioner Hickey got his party out of its reserved seats in Section G and into a safe area by the victory gardens to the south of

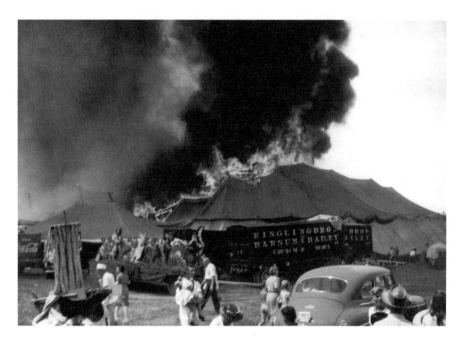

View from the southeast corner of the circus lot near the performers' dressing tent, looking west, about ninety seconds after the fire started. Fire had already consumed nearly half of the big top. Men can be seen lifting the canvas sidewall to help others escape. *Photo by L.B. Ulrich, from author's collection.*

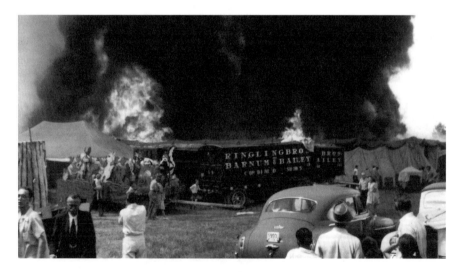

View from the southeast corner of the circus lot near the performers' dressing tent, looking west, about three minutes after the fire started. Thick black smoke fills the sky as scraps of burning canvas float to the ground. *Photo by L.B. Ulrich, from author's collection.*

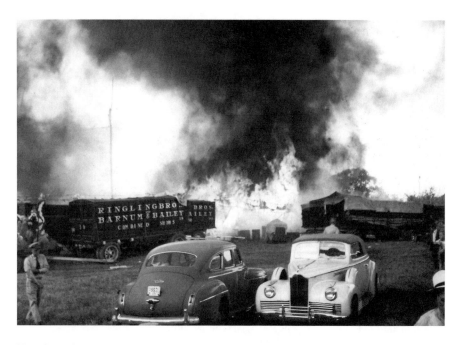

View from the southeast corner of the circus lot near the performers' dressing tent, looking west, about six minutes after the fire started. The entire big top is consumed by fire. Few survivors made it out after this point. *Photo by L.B. Ulrich, from author's collection.*

the grounds just as the big top collapsed, less than ten minutes after he first heard the cries of "Fire!" Hickey made his way along the outside of the ruins to the main entrance and found Hartford's Chief Hallissey in a police cruiser communicating with headquarters. He told the chief to inform State Police Headquarters of the disaster and to have the State Armory opened for use as a morgue for the victims of the fire. As soon as the fire site had cooled enough to allow it, Hickey went to the southwest bleacher area, the most intact of the seating areas after the fire, and began his investigation.

Ringling's tractor drivers had hitched the animal wagons and were hauling them out of the fire's reach when the city's firefighters arrived on scene. Other circus hands were leading horses, elephants and camels out to Barbour Street and the surrounding yards. Hartford Fire Department's fire alarm operator received numerous alarms from call boxes, beginning at 2:44 p.m., and most of the department's engine companies in the vicinity were dispatched to the scene as the calls continued to come in. Engine 2 responded from Main Street, about a mile and a half away from the scene.

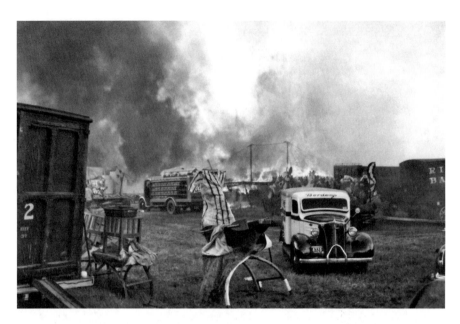

View from the southeast corner of the circus lot near the performers' dressing tent, looking west, about ten minutes after the fire started. The canvas big top roof has fallen and the flames will soon consume the few remaining poles and ropes. *Photo by L.B. Ulrich, from author's collection.*

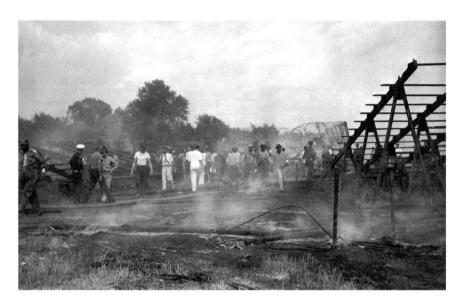

View from the main entrance end of the big top, looking east. The fire began behind the southwest bleachers, which can be seen on the right. Circus employees, policemen and curious civilians wander about the smoldering ruins. *Photo by Culver Pictures, Inc., from author's collection.*

It was the first engine on the scene and stretched six hundred feet of two-and-a-half-inch hose along the south side of the lot to spray water about four minutes after receiving the alarm. Firefighters were told by a witness that a man had fallen through the seats in grandstand Section C, and they directed the stream on that area. They found the man, who was beyond help, and redirected their focus to other areas.

Engine 3 stopped on Barbour Street, and with elephants dangerously close to them, firefighters connected to the hydrant and ran a line through the main entrance. They worked their way into the burning ruins with the hose, seeing numerous dead bodies along the way. Engine 7 arrived on scene and added two hundred feet of hose to Engine 2's lines, and Engine 16, from Blue Hills Avenue about a mile and a quarter away, responded with three men. They tied to the hydrant on Barbour Street, laid one thousand feet of hose with help from civilians and had water flowing six minutes after receiving the alarm. Truck Company 4 responded but was stopped on Barbour Street at the entrance to the circus grounds by oncoming fire apparatus; the firefighters got out and helped another engine company stretch lines. The tent was gone at this point, but the seating that remained was still on fire.

In the months prior to the circus fire, the city of Hartford's Fire Prevention Bureau had requested and been granted generous supplies of steel required for the construction of fire escapes in the city's buildings and had worked aggressively to provide additional exits as required in public assembly buildings and lodges. Hartford fire marshal Henry Thomas, by appointment from former mayor Spellacy, also served with the Hartford Fire Department as deputy to Chief King and had twenty-six years with the department. His duties as local fire marshal included investigating fires despite no formal forensic training, and Hartford city court considered him a qualified witness with regards to fire investigations. By ordinance, it was his duty to report fire hazards and egress obstructions at places of public assembly to the state fire marshal and to order such offenses removed by the owner. As local fire marshal, he inspected the city's buildings regularly, but it had not been a custom of his or his department's to inspect the circus grounds. Such an inspection would have revealed the flammability of the canvas, inadequacy of the exits, obstruction of the exits by the animal runways and absence of fire extinguishers inside the big top. But tradition prevailed, and no inspection was made. Furthermore, the Hartford Fire Department maintained that it was never officially aware of the circus being in town, not having been informed by any representative of the circus or any

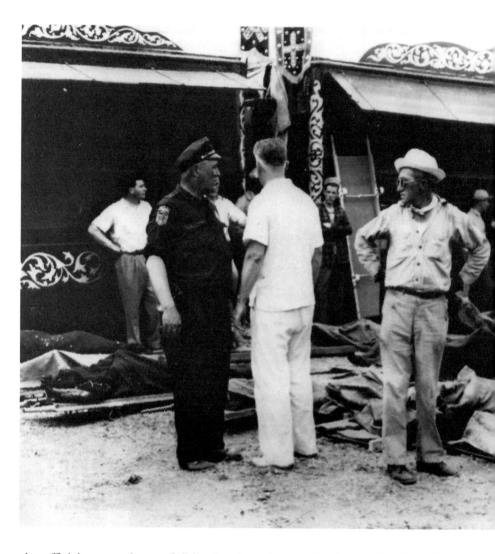

city officials or employees. While the circus had to obtain permits from the police and building departments, nothing was required from or requested of the fire department. No complaints or reports were made to the fire marshal or the chief regarding any hazardous conditions on the circus grounds in 1944 or any year prior.

Deputy Fire Chief Thomas arrived on scene about 2:47 p.m., entered the grounds from Barbour Street and supervised the firefighting. As he passed through what minutes before had been the main entrance, he saw complete destruction and bodies with various degrees of burns to his left and right. The seating structures were all still burning, and there appeared

Servicemen, police and medical personnel stand near circus wagons among dead bodies awaiting transport to the State Armory for identification. International News *photo, from author's collection.*

to be more bodies under some of them. The entire big top canvas had been consumed, roof and sidewall. Support poles had fallen, crushing whatever they landed on, and were still burning. Any remaining ropes and rigging that hadn't been consumed by the flames was strewn about the ruins. Thomas made his way to the far end of the tent, to the northeast exit, where the bodies were piled five deep alongside the steel cage animal runway.

Hartford's Assistant Police Chief Sullivan went out the Barbour Street entrance and instructed the policemen to get all cars with stretchers into the main tent and for them to drive over the sidewalk or fire hose if necessary. He made his way along the north side of the grounds to the east end, where he met Officer Kenefick. Kenefick led him to the northeast exit, where he saw a number of bodies against the steel runway and piled on top of one another. Firemen continued to spray water on the ruins, watching for survivors. When the heat subsided, circus employees, policemen and civilians helped carry the dead outside of the remains of the tent to await the medical examiner.

Boards were used as slabs so that a few bodies could be carried at one time, since many were fused together. They were taken to the back lot, where they could be removed discreetly from the scene, and were covered with some nearby canvas. Emergency ambulances from Sage Allen, G. Fox and other area businesses arrived to take the injured to hospitals. Policemen were ordered to rope off the entire scene and to not allow any circus personnel to leave the grounds.

State police commissioner Hickey, having been in attendance at the circus when the fire began, directed a crew of policemen, servicemen, doctors and civilians on the scene to remove the dead from the back lot of

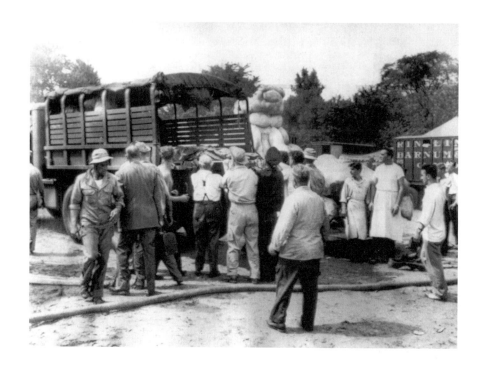

the circus grounds. News of the fire was spreading, and concerned parents were rushing to the scene to find their children as uniformed officers kept the spectators back. Hickey made arrangements with Governor Raymond Baldwin and the State War Council administrator to use Hartford's State Armory building, home to many of the State War Council offices, as a temporary morgue for the increasing number of victims of the circus fire. The state medical examiner, Dr. Walter Weissenborn, and Hartford County coroner Frank Healy authorized the removal of the dead from the circus grounds, and while all available ambulances were being used to transport the injured to hospitals, the dead were loaded onto large army trucks from the back lot. The bodies were taken to the Broad Street entrance of the State Armory, through the West Archway, where identification officer William Menser of the state police and a crew of assisting officers tagged each one as it was brought in.

The victims' bodies were removed from the trucks, placed on cots at the State Armory and inspected upon arrival. Most of their hands were burned, making fingerprinting impossible, and any paper identification the victims might have carried had been reduced to ash. Clothes were burned off or melted to the bodies, and faces were charred beyond recognition; identifications were expected to be difficult. Officer Menser, Dr. Weissenborn and Hartford dentist Dr. Edgar Butler recorded in a notebook, as best as they could with what they had to work with, the approximate age, height, weight, hair color and head circumference of each victim, and notes were made about any surgical scars, dental work, clothing and jewelry that were found on the bodies. After examination, each body was covered with an army blanket and a numbered state police casualty tag with identification information attached before it was laid out on the north end of the drill shed floor, separated into four groups: boys, girls, adult males and adult females. Nurses patrolled the rows of cots, assisting dentists and examiners as needed.

Opposite, top: Rescue workers and volunteers load bodies into an army truck to be taken to the morgue at the State Armory in Hartford for identification. *AP Wirephoto, from author's collection.*

Opposite, bottom: View of the drill shed floor at the Connecticut State Armory on Broad Street in Hartford, where a makeshift morgue was assembled for the victims of the circus fire. *Photo courtesy of Connecticut State Library, State Police Investigation Files, RG161.*

Lost children were collected at the Brown School, corner of Market and Talcott Streets in Hartford, until their parents came to claim them, such as the girl and her mother shown here. *Photo courtesy of Connecticut State Library, State Police Investigation Files, RG161.*

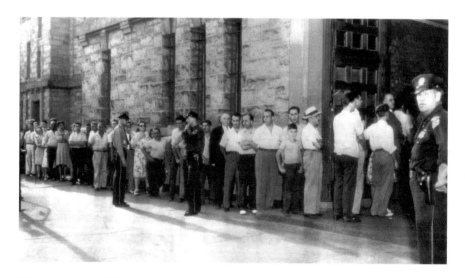

Men, women and children await their turn to view the dead at the temporary morgue set up at the State Armory building on Broad Street in Hartford. *AP Wirephoto, from author's collection.*

Ten children were held at police headquarters two hours after the fire, being cared for by policewomen in the courtroom, and other lost children were held in patrol cars, homes and businesses around the circus grounds. With the State Armory already being used as a temporary morgue and experiencing a high amount of traffic, Hartford's oldest school, the Brown School, was designated as a clearinghouse for lost children. All of the children that the police department had been collecting were taken to the school, and all officers at the fire scene were informed to send any other lost children they found to the school on Market Street. Three classrooms and the main hall in the Brown School were opened, as well as the playground, and volunteers from the Red Cross and American Legion worked with Hartford Police and auxiliary policewomen to record names and details of all lost children as they were brought in. Efforts were made to contact their relatives, and volunteers strived to keep constant coordination with the lists at the hospitals. Eight hours after opening the Brown School, with all children returned to their families, the weary staff locked up at 12:30 a.m.

Heavily guarded by soldiers and policemen, the crowd gathering at the entrance to the State Armory was growing all afternoon. A state police vehicle patrolled the street with a loudspeaker, keeping people informed with the lists of injured received from local hospitals and instructions on how to register to view the bodies. At 5:00 p.m., a dozen people at a time were admitted to view the bodies. Only those genuinely searching for a relative or close friend were allowed to enter, while others were denied entry by guards. Refreshment stations were set up by the Red Cross and the Salvation Army both inside and outside the armory, and a nurse's station was created in the lobby to tend to those grieving and in need of care. A few people who fainted and collapsed during the whole ordeal were tended to promptly.

The State Armory, also used as a distribution center for nurses and nurses' aides who had been summoned from surrounding areas, was staffed with members of the State War Council and the Red Cross after the disaster. Extra phones were installed to handle the high volume of calls from relatives and friends of missing persons and to keep close communication with hospitals, emergency personnel and the media. Those looking for a loved one entered the armory on the main floor, where they registered with the clerks and provided information about who they were looking for. They were next taken upstairs to the temporary morgue that had been assembled on the floor of the drill shed, escorted by a state police officer and a nurse. They were led to the appropriate area, depending on the age and sex of whom

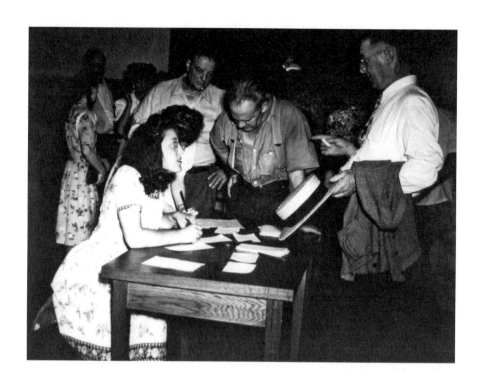

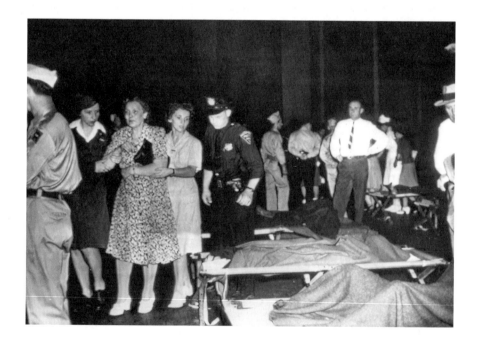

they were looking for, and began their search. With the tags providing a general idea of who was beneath the blanket, searchers were alleviated from having to view every corpse on their quest to find whom they sought.

Even after viewing the body they believed to be of their relative or friend, many still could not be certain due to the condition of the remains. Jewelry, particularly engraved rings, watches and bracelets, was useful for making positive identifications, and scars from Caesarian deliveries and appendix and hernia operations helped in some cases. One boy was identified by a doctor who noticed evidence of a circumcision he had performed on the boy just days before the fire. Dental charts were sent from surrounding towns and used in several cases, though many of the victims were children who had never visited a dentist. Many people returned for a second or third viewing before they were convinced that their loved ones were really one of the grossly disfigured bodies that they had seen.

Once identified, a body would be removed on a stretcher to a station where the state police identification tag was removed and filled out with the name of the deceased, the identifier, the medical examiner and the undertaker, and the same was filled out on a master sheet. After being cleared by the medical examiner, Dr. Weissenborn signed the death certificates, and the bodies were removed by undertakers through the Armory's East Archway. In all, 2,500 people viewed the bodies in the State Armory morgue, and 127 dead were transported there from the circus grounds; 3 more unidentified bodies were taken there from Municipal Hospital. All but 70 were identified by one o'clock Friday morning, July 7, when the armory closed until 8:00 a.m., when viewing would resume. By midnight on Friday, all but 15 had been identified. These unclaimed bodies, decomposing rapidly in the July heat, were removed to the refrigerated Hartford Hospital morgue, where 9 were identified, leaving 6 unclaimed on Sunday night, July 9. Photographs were taken and dental X-rays were made in case anyone came forward at a future date looking to make an identification, and the bodies were turned over to six Hartford undertakers, who provided caskets and prepared them for burial on Monday morning.

Opposite, top: The information desk at the State Armory building, where a temporary morgue was assembled for the identification of those who perished in the circus fire. These men rushed to the armory from work looking for their wives and children. *Photo courtesy of Connecticut State Library, State Police Investigation Files, RG161.*

Opposite, bottom: Two nurses and a policeman accompany a distraught woman searching for a loved one among the dead in the temporary morgue set up at the State Armory in Hartford. *Associated Press photo, from author's collection.*

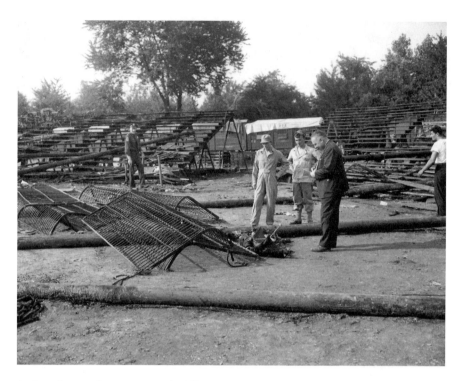

An investigator takes notes near the fallen animal runway in front of the northeast bleachers. Many of the dead were found piled up near these runways, which had prevented a quick escape from the burning big top. *Photo by Acme Photo, from author's collection.*

Commissioner Hickey, in his capacity as state fire marshal, met with deputy fire marshal Frank Starkel at the fire site early in the evening of July 6 and initiated an investigation to determine the origin and cause of the fire. Interviews and questioning began at 11:00 p.m. and continued through the night. On Friday, July 7, five Ringling men were arrested on charges of manslaughter: vice-president James Haley, general manager George Smith, boss canvas man Leonard Aylesworth, chief electrician Edward Versteeg and superintendent of the Trucks and Tractors Department David Blanchfield. Also accused but not arrested were seat men William Caley and Samuel Clark; Clark was a seat man under the south grandstand and ran out of the big top as soon as he noticed the fire. Charges against Clark were later dropped.

On Saturday night after the fire, July 8, Officer Francis Whelan and Lieutenant Henry Mayo from the State Police Department separately went undercover for the evening in the barroom of the Bond Hotel in Hartford, mingling with Ringling performers who were enjoying some spirits. The

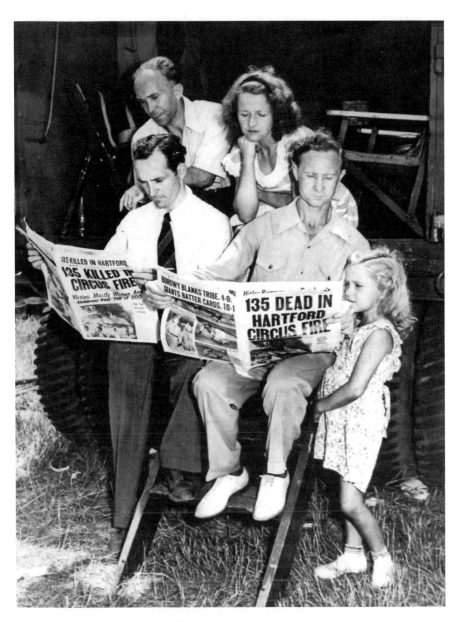

Members of the Flying Wallendas high wire act read the news after the fire. Five members of the troupe were on their platforms thirty feet above the ground when they spotted the fire. *Photo courtesy of Connecticut State Library, State Police Investigation Files, RG 161.*

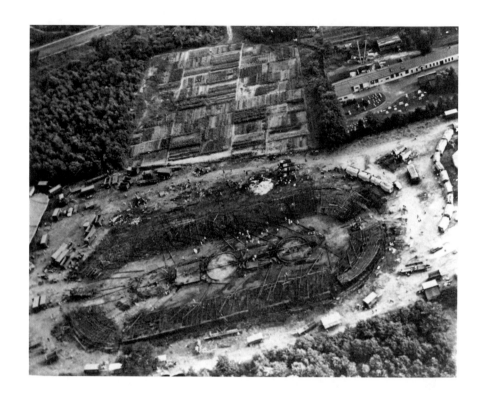

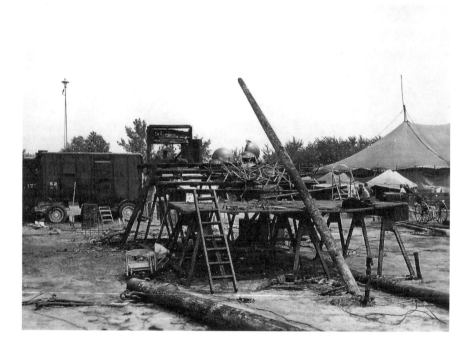

detectives listened in on conversations and tried to get in with the circus folks, taking notes for later review. Much of the talk that the detectives overheard during the night was from angry circus workers who were hurt by the treatment they were being given by the city. Some were particularly critical of Hartford's fire department, which the performers believed was the only department in a city they had played that didn't protect the circus grounds, and of a press report blaming the circus workers for caring more about their animals and equipment than for human lives. One worker told of breaking the cameras of several amateur photographers taking pictures during the fire.

Over the course of the evening, Whelan was able to make acquaintance with Ringling clown Felix Adler, who speculated that a drunken patron probably threw a lit cigarette into the men's room waste bin. The pair would continue drinking at the Spinning Wheel, where they met more performers. A group of them, including Adler and Whelan, capped the night at a private coach in the rail yard, where select people were able to buy drinks. Whelan's investigation began to derail when one of the men in the group began acting suspicious of the circus folks. Whelan offered the man a ride back to the Bond Hotel and ended up taking him to headquarters for questioning. The suspicious man turned out to be a Stamford firefighter on his own personal investigation who had had a bit too much to drink. Nothing overheard by the undercover detectives warranted any further investigation.

Investigators continued visiting the site during the weeks following the fire. Fire marshals tested the pressure of Ringling's water trucks on July 7 and seized some seating support jacks from the southwest bleacher area. A seating jack from the fire's origin, about twenty feet to the right of the main entrance, was observed to have experienced a deeper state of burning than its neighboring jacks, indicating to investigators that this jack had experienced either a more intense burning than the others or a longer duration of burning, exactly which one was a controversial subject among the investigators. The suspicious jack and the adjacent ones were removed from the site and entered as evidence. Fire Marshal Thomas's opinion was

Opposite, top: Aerial view of the Barbour Street circus grounds after the fire. Victory gardens can be seen in the upper center of the image. The performers' dressing tent is on the left, and the main entrance area is on the right. *AP wirephoto by Abe Fox, from author's collection.*

Opposite, bottom: View of the east end of the big top area with the remains of Merle Evans's bandstand in the foreground. The performers' dressing tent is on the right. *Photographer unknown, from author's collection.*

that with the canvas being more flammable than the wood jacks, the fire should have gone up the canvas, which it did, but he believed that something caused the flames to remain at this particular jack longer than the others. He could not determine, however, if the fire was accidental or incendiary.

A sheet of canvas remaining from the men's toilet area and another from the menagerie sidewall were recovered on July 13 and tagged as evidence, and Lieutenant Frank Shaw of the state police took photographs of the site for further examination. Fire Marshal Thomas also collected and reported on the circus's firefighting equipment and noted the locations of the water buckets that remained in the arena.

Commissioner and fire marshal Hickey was born in 1891 and grew up in Hartford, working at Pratt and Whitney and as a postal carrier as a young man before beginning what would be a long and illustrious career as a man of law enforcement and crime prevention. Hickey found work with the Pinkerton Detective Agency before becoming a special agent for the U.S. Department of Justice in 1916, which in turn led to work with the U.S. Bureau of Naval Investigation toward the end of the First World War. In 1922, state's attorney Hugh M. Alcorn recommended Hickey for the position of Hartford County detective, and he was promptly appointed.

Hickey and Alcorn would become a formidable team over the next seventeen years, and the Prohibition era offered them many opportunities for fighting crime. Hickey organized raids of speakeasies, nightclubs, pool halls and the like throughout the county and kept the courthouse full of bootleggers, gamblers and Prohibition violators. The two gained national attention for their part in the capture and conviction of America's first "Public Enemy Number One," Gerald Chapman, who was executed in 1925 for the murder of New Britain police officer James Skelly. Alcorn became known as "the hanging prosecutor" for the outstanding number of men he had sent to the "the upright jerker," Connecticut's method of capital punishment at the time. Hickey and Alcorn would remain together in this capacity until Hickey's appointment to state police commissioner by Governor Raymond Baldwin in 1939.

Hugh Alcorn, who retired after thirty-four years as state's attorney in 1942, was in attendance at the circus on July 6 with his son Howard Alcorn, a Superior Court judge, and Howard's wife and children. Seated in the same section as Commissioner Hickey and his party, the Alcorns escaped by jumping from the top row of seats; the men jumped first and caught the others when they leaped. Another son of Alcorn's, Hugh M. Alcorn Jr., succeeded his father after his retirement and was the active state's attorney

in 1944. Boxes of personal items collected from the circus grounds after the fire were kept in his office as he and investigators prepared a case against the circus. Among the items were several crucifixes, a rabbit's foot keychain and other lucky charms, eyeglasses, an umbrella and a Girl Scout pin still attached to a pocket torn from a child's uniform.

Letters with various theories and speculation were sent to Commissioner Hickey in the weeks following the fire. An anonymous witness reported seeing two army planes fly over the big top before the fire started and suspected that sparks from the planes ignited the tent. Another witness reported seeing a pile of two hundred fire extinguishers in the menagerie tent. An auxiliary officer reported to Commissioner Hickey that he was approached after the fire by a circus employee who told him that he saw a flash from the spotlights at the top of the pole on the west end ignite the canvas. Then he disappeared into the crowd and could not be found.

On July 10, a prisoner doing time at Montana State Prison informed the warden that he had information about the Hartford circus fire that might be of interest to investigators. Warden John Henry, an acquaintance of the Ringlings in Montana, contacted Commissioner Hickey with the information, and Detective John J. Doyle of the Connecticut State Police was sent to Montana to interview inmate Ralph Bever. Bever claimed to have worked with the circus in 1943, assigned to a water truck with a man named Cox. Cox was fired by Blanchfield for drunkenness and said in Bever's presence that he'd burn the show down and it wouldn't get far in 1944.

Efforts to locate Cox took Connecticut detectives all over the eastern United States, with them interviewing witnesses and chasing leads for Cox in Chicago, Nashville, Miami, Williamsburg, Baltimore and other cities. Detective Doyle met with Ringling's James Haley, who expressed his approval that Commissioner Hickey was having his men chase down leads and indicated to the detective that he and the circus folks felt that the fire was arson and they wished Hickey would talk to them about it. Ringling's David Blanchfield joined Haley and Doyle, and they reviewed the circus's employee records looking for the man Bever had described. All signs pointed to a man named Emmett Welch being the man Bever was talking about, as no one named Cox fit the profile. Welch had worked the water truck with Bever during the time frame given, and it was noted in his file that he had been fired several times for being drunk. In September 1944, Emmett Welch was found in Florida, being held by Miami police on charges of failing to pay a hotel bill. Detective Doyle went to Miami to interview Welch, who admitted that he knew Bever but

didn't know why he would say such things about him. He denied much of the information that had been provided by Bever, particularly the history as an arsonist and the threats to burn the circus down. The facts revealed that Welch was working as a bus driver in Miami during the fire, and he was ruled out as a suspect.

On July 18, 1944, former circus employee Roy Tuttle was brought in to Maine General Hospital in Portland, two hundred miles from Hartford, with severe burns on his legs and arms. Tuttle was known around Portland as homeless and prone to apoplectic fits, and he did odd jobs when an opportunity arose. He joined the circus in Portland a week before the fire to help erect bleacher seats, a job for which he was paid with food and free passes. He traveled with the show to Providence and on to Hartford, and when the big top caught fire on July 6, he was walking down Barbour Street and ran to help. He blacked out near one of the animal runways and woke up in a nearby field, where he spent the night. He started hitchhiking to Maine the next morning, and along his journey, when the pain from his burns became unbearable, he would find a body of water to sit in for relief, fully clothed, which led to his burns becoming infected. On July 19, Sergeant Adolph Pastore was detailed by Commissioner Hickey to Portland to question the hospitalized man, but the sergeant did not find any evidence that Tuttle started the fire.

About a month after the fire, Commissioner Hickey called on New York City fire marshal Thomas Brophy to visit the circus grounds and review the testimonies, photographs and evidence that was collected from the scene and provide his opinion as an expert on the cause and origin of fires. In charge of the Fire Investigation Bureau of New York City and with his nearly twenty years as fire marshal and over thirty-seven years of experience as a fire investigator, Brophy studied the documents and the fire scene and was especially interested in the bleacher support jack that was previously collected as evidence. The burn pattern on this particular jack was evidence of more intense burning than on the adjacent jacks, suggesting the fire began in this section of the big top, forty feet south of the center of the main entrance. The undersides of the blue bleacher planks were well burned to the north of this jack, and the planks just to the south of this jack had minimal fire damage. Ten feet to the south, the next seating jack was barely scorched, while all other jacks and seating components in the arena were in the advanced stages of destruction, further evidence that the origin of the fire was at the heavily charred jack and that the flames traveled north.

Unable to unequivocally determine the cause of the fire, Brophy indicated that while the seating jack would not have been ignited by a carelessly discarded cigarette or match, he believed it was possible that the bottom of the sidewall canvas, or possibly a pile of dried grass at the base of the jack, was ignited in this manner and the ensuing fire spread to the jack. Alternatively, a piece of burning roof canvas falling from above and landing at the base of the jack could have done the same. Fire marshal Brophy's investigation, while providing a clear origin of the fire, lacked the evidence he needed to determine whether the fire was accidental or the act of an arsonist.

Chapter 4
THOSE WHO DIED

I was called to duty with the State Guard to help control traffic and the crowds at the Armory looking for their loved ones. The smell of burned flesh from the bodies that were laid out on the drill shed floor permeated everything in the area—it was awful. Less than a year later, at the Battle of Okinawa, the same smell was evident with the Japanese troops who were scorched by flamethrowers, and I immediately thought of the circus fire.

DAVID GIBBONS

The official death toll of the fire, as reported by the board of health, was 168, which included a collection of unidentified parts as an individual victim. The estates of the 167 named victims were awarded death settlements by the arbitration board ranging from $4,000 to $15,000, the maximum allowable, with the estates of the oldest victims and preschool-aged children receiving the lowest amounts and bread-winning fathers the highest awards. In addition to these 167, three others died in the months following the circus fire—Katherine Kullick, Evelyn Sartori and Anna Thompson—and their lives appear to have been shortened as a result of injuries and complications from the fire. The estates of these additional three victims also received settlements for their injuries, comparable to those awarded to other women in their age groups who were killed in the fire, but not specifically for their deaths.

The names of these 170 people who lost their lives due to the Hartford Circus Fire, and a little information about each of them, are remembered on the following pages.

Mrs. Mary D. (Sicuranza) Abatte, age thirty-four, and her son Donald R. Abatte, five, of Ashford Street, Hartford, were both found seriously injured at the circus grounds after the fire and taken to Municipal Hospital for treatment. Despite the efforts of the staff, Donald passed away during the early morning hours of Friday, July 7, and his mother died that night at the hospital. Mary left behind her husband, a daughter and another son.

Mary Abatte, thirty-four, victim of the circus fire. *Photo courtesy of Jevan Walker.*

Mrs. Gertrude (Wylie) Adams of May Street, Hartford, widow of Howard Eldridge Adams, was born on January 19, 1882, in Mulgrave, Canada, and was found dead with grandson Roy Bell Jr. at the circus grounds after the fire. A gold wedding ring was found on body 1549 at the State Armory morgue, which was identified as Mrs. Adams by her son-in-law.

Miss Elaine Barbara Akerlind, age fifteen, of Colonial Street, Hartford, was found dead at the circus grounds after the fire and was identified as body 2104 at the State Armory morgue by her brothers-in-law, who were able to recognize a ring with a missing stone that Elaine was wearing, given to her by her sister. Miss Akerlind was intending to resume her studies as a junior at Bulkeley High School in September. She also had recently been accepted in the nurse's aid program at Hartford Hospital and was waiting for assignment. She frequently took care of children to earn money for the household after the death of her father, John Akerlind, in October 1942 and was looking forward to finding paid secretarial work when she turned sixteen in the fall.

Elaine Akerlind, fifteen, victim of the circus fire. *Photo courtesy of Connecticut State Library, Hartford Circus Fire Claimant Files, RG003.*

Frederick Baker, sixty-three, victim of the circus fire.
Photo courtesy of Connecticut State Library, Hartford Circus Fire Claimant Files, RG003.

Frederick Brooks Baker, age sixty-three, of Bolton, Connecticut, was found dead at the circus grounds after the fire and later identified as body 1515 at the State Armory morgue by his son-in-law. Mr. Baker left his wife, Bertha, and their two daughters.

Mrs. Gladys Mary (Morin) Barry, age forty, and her daughter, Gail Ann Barry, age five, of Curtiss Street in Hartford were both found dead at the circus grounds after the fire and later identified at the State Armory morgue by Gladys's sister-in-law. Gladys, a part-time piano teacher, left her husband, Hartford firefighter Vincent Barry.

Mary "Peanut" Bedore, thirteen, victim of the circus fire. *Photo courtesy of Connecticut State Library, Hartford Circus Fire Claimant Files, RG003.*

Miss Mary Frances "Peanut" Bedore, age thirteen, of Barkhamsted, Connecticut, was found dead at the circus grounds after the fire and later identified as body 2111 at the State Armory morgue by her father. Mary's uncle Frederick Wabrek also lost his sister, Loraine, and his mother, Anna, in the circus fire. Miss Bedore left her parents and her sister.

Roy Ritchey "Rickey" Bell Jr. of Amityville, Long Island, New York, born on September 21, 1937, in Hartford was found dead with his grandmother Mrs. Gertrude Adams at the circus grounds after the fire. Rickey's father, a sheet metal mechanic in the aircraft industry, identified body 4504 at the State Armory morgue as his son.

Miss Eldoras Dovetta Bergin, age eighteen, of New Hartford was found dead at the circus grounds after the fire and was identified as body 1583 at the State Armory morgue by her mother. In addition to her parents, Miss Bergin left a sixteen-year-old sister. Prior to her death, Eldoras worked on a poultry farm.

Mrs. Mary E. (Collins) Bergin, age seventy-two, and her daughter, Miss Mary F. Bergin, age forty-nine, both of Lincoln Street in Hartford, were found dead at the circus grounds after the fire and later identified on July 7 by Reverend Leary. They left John Bergin, who would join his wife and daughter in eternal rest just two months later, on September 5, 1944. Miss Bergin was employed as a secretary at the Royal Underwood Typewriter Company in Hartford.

Mrs. Rose Catherine (Pierson) Berman, age thirty-nine, and her daughter, Judith Ann Berman, seven, of Wethersfield, Connecticut, were both found dead at the circus grounds after the fire and were later identified at the State Armory morgue as bodies 1586 and 1507. Rose, a former Meriden High School teacher, left her husband, Hyman, owner of Berman's Department Store. Judith was a student in the third grade and also took dancing lessons.

Miss Ann L. Berube of Church Street in Plainville, Connecticut, born on July 10, 1938, was found dead at the circus grounds after the fire and was identified as body 1524 at the State Armory morgue by her father. Miss Berube, who left her parents and infant brother, was buried at St. Joseph's Cemetery in Plainville on July 10 on what would have been her sixth birthday. She attended the circus with her mother, Esther, whose left leg was broken in three places while trying to escape the burning tent, and the Murphy family from Plainville: Walter, Hortense, Charles and Patricia. Only Esther and Patricia survived.

Mrs. Marguerite Ruth (Palmer) Birch, age thirty-six, of Meriden, Connecticut; her son, Arland Edward Birch, twelve; and her daughter, Shirley Ann Birch, nine were all found dead at the circus grounds after the fire. Lawrence Birch identified bodies 1567, 1570 and 4586 at the State Armory morgue as his wife and children. Marguerite's body was found with three rings, which helped with identification.

Circus fire victim Sarah Booth, sixty-seven. Her daughter and granddaughter also perished in the fire. *Photo courtesy of Connecticut State Library, Hartford Circus Fire Claimant Files, RG003.*

Frank Bradley, thirty-seven, victim of the circus fire. *Photo courtesy of the Simsbury Volunteer Fire Company.*

Mrs. Sarah Sophia (Hahn) Booth, age sixty-seven, of Ashley Street in Hartford was found dead at the circus grounds after the fire and was later identified at the State Armory morgue as body 2117 by her husband, Roy. Mrs. Booth attended the circus with her daughter Lola Mather and granddaughter Sarah, both of whom also lost their lives in the fire.

Mrs. Alice A. (Kirkorian) Boyajian, age thirty, and her sons Frederick K. Boyajian Jr., five, and Stephen F. Boyajian, three, of Hillside Avenue in Hartford were all found seriously injured at the circus fire and taken to Municipal Hospital, where they died later that evening. Alice left her husband and their infant son.

Frank Benson Bradley, age thirty-seven, and his wife, Helen Alicia "Alice" (Leonard) Bradley, thirty-five, of Simsbury, Connecticut, took their daughters to the circus and were killed when they went back inside the burning tent to find their girls, who had already escaped. Bodies 1514 and 1545 were identified as Frank and Helen at the State Armory morgue; on Frank's body was found a watch and a chain. Earlier in 1944, Mr. Bradley had been one of seventeen men who formed what became known as the Simsbury Volunteer Fire Company.

Mrs. Dorothy Elaine (Morrison) Brooks, age forty-four; her daughter, Miss Dorothy Elaine Brooks, twenty; and her sons, James Frederick Brooks, ten, and George Albert Brooks, nine, of Plainville, Connecticut,

were all found dead at the circus grounds after the fire on July 6. Bodies 2107, 1571, 1506 and 4503 went unclaimed at the State Armory morgue and were moved to the Hartford Hospital morgue on July 8, when Frank Brooks Sr. identified the bodies as his wife, daughter and sons. Mrs. Brooks was found wearing pink pants and a pink corset and had rings on her right and left hands. Miss Brooks, also found wearing a ring, was a college student studying at the University of New Hampshire and was home on summer break when she accompanied her mother and brothers to the circus.

Miss Edith Wickham Budrick, age nine, of East Hartford was found severely injured at the circus grounds after the fire and was immediately admitted to Municipal Hospital with deep fourth-degree burns to 35 percent of her body surface and in profound shock. Edith was treated with morphine and plasma and retained consciousness for a few hours until her condition worsened, and she succumbed to her injuries later that evening. Miss Budrick's brother, Joseph Charles Budrick Jr., seven, was found dead at the circus grounds after the fire, and their mother, Mrs. Edith May (Wickham) Budrick, thirty-eight, was assumed to have died in the fire, though her body was never identified. Mrs. Budrick, whose sister, Viola Locke, and niece Elaine were also victims of the circus fire, had been listed as missing; her sister-in-law confirmed that the family was positive that Edith's body was not one of those at the State Armory morgue. She was described as five feet tall, 106 pounds and wearing a platinum wedding band with engravings, which was never recovered. The Budricks left husband and father, Joseph Budrick Sr.

Miss Annie Frances Burns, age sixty-four, of Thomaston, Connecticut, was found seriously injured at the circus grounds after the fire and was admitted to Municipal Hospital for treatment. Despite the efforts of the hospital staff, Miss Burns died from her injuries shortly after noon on Friday, July 7. Annie, formerly employed at the Seth Thomas Clock factory in Thomaston, left her sister and brother-in-law, with whom she resided, and her nephew, Dr. Enos O'Connell, whose wife and daughter—Eveline and Doris Jean—were also victims of the circus fire.

Miss Jacqueline A. Carrier, age four, of Orange Street in Hartford was found dead at the circus grounds after the fire and was later identified as body 1532 at the State Armory morgue by a relative. She attended the circus with her aunt Alice DuHamel, who was also a victim of the fire.

Edward Clark and his wife, Emily, victims of the circus fire. *Photo courtesy of Connecticut State Library, Hartford Circus Fire Claimant Files, RG003.*

Walton Eugene Charter, age fifty-three, of Campfield Avenue in Hartford was found dead at the circus grounds after the fire and was later identified as body 1519 at the State Armory morgue by a dentist. Walton, who had been employed as a machinist at the Underwood Elliott Fisher Company, left his wife and two adult daughters.

Edward Ralph Clark and his wife, Emily Eliza (Jacobs) Clark, both age eighty-one, of Webster Street in Hartford were found dead at the circus grounds after the fire and were later identified as bodies 1543 and 2164 at the State Armory morgue by a dentist. The couple left two sons and their daughter, Grace, who was also injured at the fire and later died from her injuries on July 24.

Miss Grace Jacobs Clark, age forty-eight, of Webster Street in Hartford was found critically injured at the circus grounds after the fire and was taken to Municipal Hospital, where she died in the early morning hours of July 24 after nearly eighteen days of supportive treatment, including the amputation of her right leg. Grace's parents, Emily and Edward Clark, were also victims of the circus fire, having both died at the circus grounds. Miss Clark, organist at the Danish Lutheran Church and a member of the Church of the Good Shepherd, left two brothers.

Mrs. Evelyn Lucille (Hull) Conlon of Elmwood, Connecticut, born on August 24, 1917, in Kingston, Rhode Island, was found dead at the circus grounds after the fire and was later identified as body 1528 at the State Armory morgue by her husband. In addition to her husband, Evelyn left her two sons, both of whom attended the circus with their mother and were injured.

Miss Rita Ann Connolly, age thirteen, and her brother Edward Francis Connolly Jr., age ten, of Eastview Street in Hartford were found dead at the circus grounds after the fire and were later identified as bodies 2163 and 1511 at the State Armory morgue. They left their parents, a brother and a sister. Prior to their deaths, both children were students at the St. Augustine School in Hartford.

Edward Parsons Cook, age six, of Southampton, Massachusetts, was found seriously burned next to his mother at the circus grounds after the fire and was admitted to Municipal Hospital, where he died the next day with his aunt Emily by his side. Edward's sister, Eleanor Emily Cook, eight, was assumed to have died in the fire, though her body was not identified at the time. The children left their mother, Mildred, who remained in a coma until August and was hospitalized until late November for treatment of her injuries from the fire; their nine-year-old brother, Donald, who attended the circus but escaped relatively unscathed; and their father, estranged from the family. The Cook children were visiting with their mother at her home on Marshall Street in Hartford, enjoying summer vacation activities with her while she had some time off work at Liberty Mutual. After Mildred and her husband separated in 1943, Mildred moved herself and the children in with her brother Theodore "Ted" Parsons. Arrangements were made for Ted and his wife, Marion, to raise the children in a family setting, and Mildred moved to Hartford to work and earn money, hoping to eventually be able to support her children on her own.

Eleanor's aunt Emily (Parsons) Gill described her niece in July 1944 for those searching for her: eight years old; four feet, four inches, "tall for her age"; light brown hair; blue eyes; and wearing a red-and-blue plaid playsuit, red socks and white summer shoes. She was also sure that Eleanor had eight permanent teeth. Emily viewed the body of 1565 multiple times on July 6 and 7 and concluded that 1565 was not Eleanor; Ted Parsons viewed the body as well and agreed with his sister that 1565 was not

Circus fire victims Eleanor Cook (center) and her brother Edward (right). Donald Cook (left) survived the fire. *Photo courtesy of Connecticut State Library, State Police Investigation Files, RG161.*

their niece. Connecticut State Police had its forensic laboratory compare combings from Eleanor's hairbrush with hair samples from 1565 and determined that the hairs matched and might have been from the same person. In 1991, it was declared that body 1565 was Eleanor, despite the fact that the body was around six years old at time of death; three feet, ten inches tall; had only 2 permanent teeth; and was wearing a flowered dress and brown shoes. The body was exhumed from Northwood Cemetery in Hartford and reburied at Center Cemetery in Southampton, next to Eleanor's brother Edward.

Mrs. Florence E. "Edith" (Brown) Corttis of Thompson, Connecticut, born on May 16, 1887, in St. Paul, Minnesota, was found dead at the circus grounds after the fire. She was identified as body 1567 at the State Armory morgue by her daughter, which was later confirmed with dental X-rays taken at the hospital and compared by telephone with records on

file with a dentist in Massachusetts and further confirmed by matching the serial number on Mrs. Corttis's watch with the records of the jeweler whose mark was on the watch. Though born in Minnesota, Edith grew up in Providence, Rhode Island, and Boston, Massachusetts, and she was a Boston College graduate. Mrs. Corttis was employed at the University of Connecticut library and resided with circus fire victims Edwin and Lucille Woodward. It was not known that Edith attended the circus until several hours after the fire when her coat was found in the Woodwards' car at the circus grounds. Also in the group with the Woodwards and Mrs. Corttis were Peter Hines, grandson of the Woodwards, and Elizabeth and Mary Putnam, all victims of the fire. Edith had previously taught at Putnam High School and Storrs College and had been instrumental in founding the University of Connecticut chapter of the Alpha Delta Phi sorority. The sorority alumnae would present a silver tea service to the local chapter as a memorial to Mrs. Corttis at a banquet in 1945. Mrs. Corttis left three daughters, three stepdaughters and two stepsons; her husband, Edgar, was killed in 1927 in a farming accident.

Mrs. Mary (Browne) Cosgrove, age fifty-three, of West Hartford was found dead at the circus grounds after the fire and was later identified as body 2165 at the State Armory morgue by a cousin. Mary was a graduate of New Britain Teacher's College and had taught at Hartford Public Schools for many years. She left her eleven-year-old son and was predeceased by her husband, Joseph M. Cosgrove, a widely known insurance man who had died suddenly at home just two years earlier.

William "Will" Lee Curlee Jr. of Euclid, Ohio, born on September 26, 1914, in Morganton, North Carolina, was found dead at the circus grounds after the fire and was later identified as body 4588 at the State Armory morgue. William and his son, David, initially escaped from the big top; Will instructed his son to wait for him by the car while he went back inside to help others. Witnesses reported that William was helping people over the animal runways when the canvas roof and supporting pole collapsed on him. In addition to his son, Mr. Curlee left his wife and his four sisters. Formerly a Hartford resident, Will was working as an inspector in the aircraft industry, assigned to the Eaton Manufacturing Company in Cleveland, and was vacationing with his family and his wife's parents in Hartford when the circus fire claimed his life. The Curlee family faced tragedy again in 1959 when Will's son, David, then twenty-two, was fatally

Katherine DeNezzo and her son, Joseph Jr., victims of the circus fire. *Photo courtesy of Connecticut State Library, Hartford Circus Fire Claimant Files, RG003.*

injured when a car he was riding in left the road and struck a tree near Provincetown, Massachusetts.

Mrs. Katherine J. (Gallucci) DeNezzo, age thirty-five, and her son, Joseph A. DeNezzo Jr., three, of Edwards Street in Hartford were found dead at the circus grounds after the fire, along with Katherine's mother and niece—Rose and Mary Jane Gallucci. Joseph DeNezzo Sr. identified bodies 2108 and 1529 at the State Armory morgue as his wife and son. Mrs. DeNezzo left her husband, Joseph, and her sister, Mary—who married each other after Katherine's death—and two brothers, John (Mary Jane's father) and Leonard Gallucci.

Miss Carolyn Marie Derby, age six, of West Hartford was found dead at the circus grounds after the fire and was identified at the State Armory morgue by her father, who recognized the red shoes his daughter was wearing, like those worn by Dorothy in *The Wizard of Oz*. Carolyn left her parents and two brothers. She attended the circus with her mother, Ethel, her brother

Circus fire victim Anna DiMartino, mother of eight children. *Photo courtesy of Connecticut State Library, HartfordCircus Fire Claimant Files, RG003.*

William Jr. and neighbors Anna and Loretta Dillus; only Ethel and William Jr. survived the fire, though with serious injuries.

Mrs. Anna Albina (Staskavich) Dillus, age thirty-six, and her daughter, Loretta Ruth Dillus, seven, of West Hartford were found dead at the circus grounds after the fire and were later identified at the State Armory morgue as bodies 1577 and 1542 by a dentist. Anna and her daughter attended the circus with neighbor Ethel Derby, her son William Jr. and her daughter, Carolyn, who was also a victim of the fire. Mrs. Dillus left her husband, George.

Mrs. Anna (Cangelosi) DiMartino of Barbour Street in Hartford, born on November 27, 1907, in Argentina was found dead at the circus grounds after the fire and was later identified as body 2115 at the State Armory morgue by her husband, Salvatore. In addition to her husband, she left eight children. Anna attended the circus with her sister-in-law Carmela Pistorio, and both were killed; they had planned on taking the children the next day. Anna DiMartino's future granddaughter Renee (Tetreault) Newell, daughter of Lillian (DiMartino) Tetreault, was a passenger on American Flight 11, which was hijacked and crashed into the North Tower of the World Trade Center in New York City on September 11, 2001, killing all on board.

William Joseph "Billy" Dineen Jr., age eight, of Martin Street in Hartford was found dead at the circus grounds after the fire and was later identified as body 1561 at the State Armory morgue by his father, Detective Sergeant William J. Dineen of the Hartford Police Department. Billy left his parents and his two sisters and was predeceased by an infant brother in 1940. Billy, a student at St. Michael's Parochial School, attended the circus with his sister Marian, a cousin and an uncle. When the fire broke

Alice DuHamel and her niece Jacqueline Carrier, victims of the circus fire. *Photo courtesy of Connecticut State Library, Hartford Circus Fire Claimant Files, RG003.*

out, Marian grabbed Billy, and their uncle took their cousin; Marian lost hold of Billy as she was climbing over the animal runways and ran toward the exit seconds before the tent collapsed on those left inside, including Billy.

Miss Alice B. DuHamel, age twenty-three, of Orange Street in Hartford was found dead at the circus grounds after the fire and was later identified as body 2114 at the State Armory morgue. Miss DuHamel attended the circus with her niece Jacqueline Carrier, who was also a victim of the fire. Alice, employed as a clerk at Associated Transport Co. in Hartford, left her mother, three brothers and three sisters.

Miss Ellen Patricia Edson of Manchester, Connecticut, born on October 27, 1940, in Plainfield, New Jersey, was found injured at the circus grounds after the fire on July 6 and was taken for treatment to Municipal Hospital, where she died from her injuries shortly after 2:00 a.m. on July

7. Ellen left her parents and no siblings. Miss Edson attended the circus with a neighbor, Miss Doris Schinkel, who was also a victim of the fire.

Mrs. Jane "Jenny" (Norden) Elliott, age forty-three, and her son Richard Edward Elliott, six, of Wethersfield, Connecticut, were both found dead at the circus grounds after the fire and were later identified as bodies 1573 and 4587 at the State Armory morgue by Jenny's brother-in-law. Mrs. Elliott left her husband and a teenaged son. Her doctor described her as having a slight build and being very active, and she always seemed healthy. Richard, who had recently finished kindergarten and was ready to start first grade in the fall, was in excellent health and a lively, active and intelligent little boy.

Raymond A. Erickson Jr., age six, of Middletown, Connecticut, was assumed to have died from injuries received at the circus fire, although his body was never identified. He attended the circus with his mother, Sophie Erickson, his uncle Stanley Kurneta, his aunts Mary and Elizabeth Kurneta, his grandmother Mrs. Frances Kurneta and his cousin Anthony, and the group sat in reserved seating Section S, four rows from the top. When Raymond's uncle Stanley noticed the fire, he led his family toward the main entrance and found that the steel animal runway at the northwest corner of the big top blocked their way. Stanley pushed Frances, Elizabeth and Anthony over the runway and got them outside before going back into the burning tent to find his sister Mary and nephew Raymond, but the intense heat forced him out. He continued his search on the circus grounds and was unable to find Mary, but he did find Raymond on a board near a circus wagon with serious burns to his face and neck, sobbing quietly. Stanley picked his nephew up, rode with him in an army truck to Municipal Hospital, then carried him to the fourth floor and placed him on a mattress in the corridor. Stanley asked Reverend Thomas McMahon to give the boy his last rites, and then he left the hospital to find the family members he had left behind. When his search led him to Hartford Police headquarters, the officers on duty took Stanley to the hospital to receive treatment for his own burns, which were so serious that he spent over two weeks hospitalized. Mary Kurneta was among the dead removed from the grounds and later identified at the State Armory morgue.

Raymond Erickson Jr. was described as six years old but with the height and build of a nine-year-old, sturdy and round faced, with straight brown hair and large hands. His arm had been broken just above the wrist a month earlier, and he had gentian violet stains on his arm from

three days earlier when a doctor treated him for a blister caused by the cast he had on his arm. His teeth were straight and well spaced; two front upper and two front lower teeth were adult teeth, and several molars had cavities. He had never been to a dentist, so no records were available. His uncle said that Raymond was fully clothed and wet when he brought him to the hospital. He was wearing a white shirt with brass buttons and a yellow stripe on the collar, blue chevrons and a blue eagle on the left sleeve with navy blue shorts, a belt with a black buckle, brown sneakers with a knot in the laces that his mother had tied that morning and blue socks. Raymond's mother, Sophie Kurneta, inspected a box of victims' belongings at Municipal Hospital and found her son's shoes with his socks tucked inside them but no other traces of the boy. All of the hospitals, the morgue, the Hartford Police Station, the local funeral homes and the coroner's office were checked and questioned about Raymond's remains and clothing, but nobody had any knowledge of him. The investigating officer declared that "some errors were made," and medical examiner Dr. Weissenborn believed that someone else had claimed Raymond as their own child. Mrs. Erickson declined to have the investigation continue, not wanting to disturb the other parents by informing them of the mistake. Raymond left his father, Raymond Sr., who was called back to duty in the U.S. Navy shortly after the fire.

Mrs. Grace Dorothy (Smith) Fifield of Newport, Vermont, was born on June 17, 1897, in Quebec, Canada. Although her body was never identified, she was assumed to have died at the circus grounds on July 6. Grace left her second husband of eleven years, her son and two daughters. Grace was visiting relatives in Wethersfield, Connecticut, with her son, Ivan, who last saw his mother ahead of him as they exited the burning

Grace Fifield, presumed to have died in the circus fire, although her body was never identified. *Photo courtesy of Connecticut State Library, State Police Investigation Files, RG161.*

81

tent. She was five feet, four inches tall, 145 pounds, had dark blond hair and was believed to be wearing a brown-and-white flowered dress, gray or white shoes, no hat or jewelry and a black handbag with about forty dollars in cash. After viewing the bodies at the State Armory morgue, Grace's husband, William, thought that his wife might have had amnesia and took a train to Canada, but it was ultimately declared that Mrs. Fifield was surely one of the dead.

James Walter Fitzgerald II, age three, of Hillside Avenue in Hartford was found critically injured at the circus grounds after the fire and was taken to Municipal Hospital, where he received supportive treatment for five days, including plasma transfusions, until he passed away during the morning of July 11. James left his parents and his six-year-old brother, David. His mother and brother were also injured in the circus fire, though not fatally.

Miss Shileen Theresa Fitzsimmons, age three, of Bridgeport, Connecticut, was found dead at the circus grounds after the fire and was later identified by her father at the Hartford Hospital morgue as body 1508, one of the final bodies to be identified. Shileen, a gifted and talented child who would have been starting school in September, left her parents and no siblings.

Mrs. Louise (Mutter) Edwards Ford of West Hartford, born on May 1, 1864, in New York City was found critically injured at the circus grounds after the fire on July 6 and was brought to St. Francis Hospital, where she passed away on Friday night, July 7. Mrs. Ford was predeceased by her husband, John J. Ford, and by her first husband, Joseph Edwards. She left a son, a daughter and six grandchildren.

Mrs. Mary M. (Rester) Franz, age thirty, and her son, William "Billy" Franz Jr., three, of Philadelphia, Pennsylvania, were found dead at the circus grounds after the fire. William Franz Sr. identified bodies 1587 and 1531 at the State Armory morgue as his wife and son. Mary and William were married in 1937 in Coventry, Connecticut, and made their home in Philadelphia, where Mary worked as a waitress at the Wood School in Langhorne, Pennsylvania, until the birth of their son. Ambitious, bright and cheerful, Mary was devoted to caring for her family and their home. In addition to her husband, Mrs. Franz left her parents of South Coventry, with whom she and Billy were visiting, and three brothers. Her sisters, Terry and Betty Rester, were also victims of the fire.

Miss Mary Jane Gallucci, age five, of Edwards Street in Hartford was found dead at the circus grounds after the fire and was later identified as body 4505 at the State Armory morgue by her uncle. Mary Jane's grandmother Rose Gallucci was also a victim of the circus fire, as well as her aunt Katherine and cousin Joseph DeNezzo. Mary Jane left her parents and no siblings.

Mrs. Rose (Puglise) Gallucci of Edwards Street in Hartford, born on September 10, 1890, in New York City was found dead at the circus grounds after the fire and was later identified as body 1546 at the State Armory morgue by her son and son-in-law. Mrs. Gallucci's daughter Mrs. Katherine DeNezzo and two grandchildren, Joseph DeNezzo Jr. and Mary Jane Gallucci, were also victims of the circus fire. Rose, predeceased by her husband, Antonio Gallucci, left a daughter and two sons.

Miss Margaret May Garrison, age sixty-nine, of East Hartford was found dead at the circus grounds after the fire. Miss Garrison, single with no children, was identified by a friend. Two years after her death, the East Hartford Civilian Service Corps dedicated their new home, Garrison Hall, to Margaret, an outstanding post worker who volunteered her services when posts were first established in East Hartford.

Margaret Garrison, sixty-nine, victim of the circus fire. *Photo courtesy of Connecticut State Library, Hartford Circus Fire Claimant Files, RG003.*

Mrs. Maurice (Wells) Goff, age twenty-four, and her daughter, Muriel Goff, four, of Bellevue Square in Hartford were found dead at the circus grounds after the fire. Arnold Goff identified bodies 4510 and 1509 at the State Armory morgue as his wife and daughter. In addition to her husband, Mrs. Goff, employed as a machine operator at Colt Firearms in Hartford, left her father, three sisters and her brother, Corporal Robert B. Wells, serving with the U.S. Army in the South Pacific.

Kenneth Gorsky, five, victim of the circus fire. *Photo courtesy of Connecticut State Library, Hartford Circus Fire Claimant Files, RG003.*

Mrs. Sylvia (Lagary) Goldstein, age twenty-seven, and her daughter, Miss Adrienne Beverly Goldstein, three, of Andover Street in Hartford were found dead at the circus grounds after the fire and were later identified as bodies 2168 and 1539 at the State Armory morgue by Sylvia's uncle Sergeant Samuel Weinstein of the Hartford Police Department. Sylvia left her husband, dentist Captain Leonard N. Goldstein, who was serving with the U.S. Army overseas; her parents of Hartford; and her brother, Morris Lagary, serving in the Philippines with the U.S. Army. Morris would also suffer a wrongful death in 1978 when he was found bound, gagged and suffocated in a locked bathroom at a business that he co-owned, Sandy's Restaurant on Asylum Street in Hartford.

Kenneth Gorsky, age five, of Main Street in Hartford was found dead at the circus grounds after the fire and was later identified as body 1562 at the State Armory morgue. Kenneth, an alert, curious and intelligent little boy who was full of questions and energy, left his parents and no siblings. He attended the circus with his cousin Shirley Kellin, who was also a victim of the fire.

Mrs. Ann (Nelson) Goulko, age thirty-six, and her daughter Miss Nancy Maureen Goulko, six, of West Hartford were found dead at the circus grounds after the fire, and another daughter, Miss Claire Margaret Goulko, seventeen, was found with them, severely burned but alive. Claire was hospitalized for treatment of burns received but died from surgical shock and congestive heart failure following a skin grafting operation on August 17, 1944, at St. Francis Hospital in Hartford. Martin Goulko identified bodies 2106 and 1523 at the State Armory morgue as his wife, Ann, and daughter Nancy on July 7. In addition to her husband, Mrs. Goulko left her son Lieutenant Burton T. Goulko, whose wife, Elizabeth, was also a victim of the fire.

Mrs. Elizabeth Josephine (Burrows) Goulko, age twenty-two, of Staten Island, New York, was found dead at the circus grounds after the fire and was later identified at the State Armory morgue on July 7 by her father. She left her husband, Lieutenant Burton T. Goulko, serving with the Ninetieth Infantry Division, U.S. Army. She attended the circus with her mother-in-law, Mrs. Ann Goulko, and sisters-in-law, Claire and Nancy, with whom she was visiting. All were burned and died on scene except Claire, whose fight for life ended on August 17, 1944. Elizabeth, a class of '43 graduate of Cornell University, married class of '42 Cornell graduate Burton T. Goulko in June 1943 while Burton was stationed at Fort Sill, Oklahoma. On August 20, 1944, Lieutenant Goulko was killed in action in France while fighting with the Allied armies and was posthumously awarded the Silver Star for conspicuous gallantry versus the enemy. Memoirs of a soldier who served with Lieutenant Goulko indicate that Burton was quite despondent in the weeks that followed the news of his family's death in the fire.

Mrs. Hulda Elizabeth (Miller) Grant, age twenty-eight, of East Hartford was found dead at the circus grounds after the fire. She left her father in New Jersey; her seven-year-old daughter, Caroline Mae Brown, who lived with Hulda; her husband, from whom she was separated; and her aunt Anna (Bishop) and uncle Gilbert Gates, with whom Hulda had lived for many years after her mother died in 1917. Hulda attended the circus with her daughter, Caroline, her friend Frank Golotto, thirty, and Donald Gale, ten, whose mother was a friend of Hulda. Mr. Golotto and Caroline escaped relatively uninjured; however, Donald was seriously burned and required extensive medical treatment. Hulda never made it out, and Frank identified her body at the State Armory morgue later that evening.

Helen Gray (standing, far left), sixty-five, victim of the circus fire. *Photo courtesy of Connecticut State Library, Hartford Circus Fire Claimant Files, RG003.*

Mrs. Helen F. (Martin) Gray, age sixty-five, of Providence, Rhode Island, was found seriously injured at the circus grounds after the fire in profound burn shock and extreme pain. She received plasma transfusions, morphine and supportive treatment for burns on her upper and lower extremities but expired as a result of cardiac arrest in the early morning hours of July 12. Mrs. Gray taught school from 1918 to 1942, including eight years serving as principal at Saylesville School in Lincoln, Rhode Island. From 1942 until her death, she was the librarian at Lincoln Memorial Junior High School and was active in many civic, charitable and church groups. Her husband, Matthew, had experienced several extended periods of illness during their marriage and required hospitalization and nursing; Helen's wages were often the primary source of income for the couple.

Mrs. Audrey Catherine (Rieger) Hager, born on July 30, 1921, in New York City, attended the circus with her husband, James, and their fifteen-month-old

son, James Jr. When the couple noticed the fire, Mr. Hager put their child under his arm and jumped to the ground behind the bleachers, thinking Audrey was right behind them. Mrs. Hager was found dead at the circus grounds after the fire and was identified as body 2170 at the State Armory morgue by her husband, which was later confirmed with dental records. The Hager family had been spending the summer living in a camper at Blish's Beach at Lake Terramuggus in Marlborough, Connecticut, and had been spending winters in East Hartford, near Mr. Hager's workplace, United Aircraft Corp. Audrey was predeceased by her first husband, Dickie Combs, a victim of polio.

Mrs. Nellie Frances (Cobb) Hart of Plainville, Connecticut, was born on April 22, 1875, in Watertown, Massachusetts, the daughter of Matilda (Lindley) and Civil War veteran Leander Putnam Cobb of Company K, Forty-second Massachusetts Infantry. Nellie was found critically injured at the circus grounds after the fire and admitted to Municipal Hospital for treatment of third-degree burns to her arms, legs, face and 45 percent of her body. Despite supportive efforts, Mrs. Hart passed away before dawn on July 25, 1944, at the hospital. Nellie, predeceased by her husband, Joseph, left three adult sons.

Miss Minnie Hess, age forty-two, of Brooklyn, New York, was found dead at the circus grounds after the fire and was later identified as body 1579 at the State Armory morgue by a relative. Minnie's watch was found with the body of Irene North, which led to some confusion with identification. Minnie was employed as a clerk at the New York City Department of Health, and her co-workers were deeply saddened by her death.

Mrs. Ada (Hall) Hindle of Norwich, Connecticut, was born on July 25, 1879, in Lancashire, England. She was found injured at the circus grounds after the fire and was taken for treatment to Municipal Hospital, where she passed away on July 26 after nearly three weeks of care. Ada, formerly a saleswoman in a hat store, left her husband, Edmund, and their adult son. She attended the circus with her grandson and her daughter-in-law, who were also burned, but not fatally.

Peter Woodward Hines of Lakeville, Connecticut, was born on July 10, 1938, the son of Ruth L. (Woodward) and Lakeville veterinarian Dr. Charles P. Hines. He was found seriously injured at the circus grounds after the fire and was taken to Municipal Hospital, where he died later that evening. Peter attended the circus with his grandparents Lucille and Edwin Woodward and

their friends Edith Corttis, Elizabeth Putnam and Mrs. Putnam's daughter Mary. No one in the party survived. Peter's mother gave birth to another son, Charles Jr., just two days after the death of her son Peter.

Mrs. Helen Marie (Magnuson) Johnson, age fifty-five, of West Hartford was found dead with her granddaughter Constance Pellens at the circus grounds after the fire. Helen, identified at the State Armory morgue on July 7 by her son-in-law, left her husband and two adult daughters.

Mrs. Esther Edith (Hoffman) Kavalier, age thirty-nine, and her daughter, Miss Sandra Lois Kavalier, six, of West Hartford were found injured at the circus grounds after the fire and were taken to Municipal Hospital. Sandra was pronounced dead upon arrival, and Esther died the following evening. Mrs. Kavalier left her husband and their young son.

Miss Shirley Ann Kellin, age sixteen, of West Hartford was found dead at the circus grounds after the fire and was later identified as body 1563 at the State Armory morgue by her father. Miss Kellin had studied at William Hall High School and was planning to attend the Oxford School. She worked part time at her father's men's apparel business and at the Youth Center in Hartford. Shirley went to the circus with her cousin Kenneth Gorsky, who was also a victim of the fire. She left her parents and her brother, Myron, twenty-two, who later became known as television and film actor Mike Kellin.

Mrs. Dorothy Elizabeth (Dennett) Kelly of West Hartford, born on September 26, 1895, in New Hampshire, was found dead at the circus grounds after the fire. Mrs. Kelly left her husband and was identified as body 2169 at the State Armory morgue by a friend.

Mrs. Helen Marie (Herman) Koob, age forty-four, and her son, Bernard Herbert Koob Jr., seven, of West Hartford were found dead at the circus grounds after the fire. B. Herbert Koob Sr. identified his wife and son as bodies 2116 and 2101 at the State Armory morgue on July 7. In addition to her husband, Helen left a seventeen-year-old daughter.

Miss Roslyn Chia "Rusty" Kruh, age twenty-two, of West Hartford was found injured at the circus grounds after the fire and admitted to St. Francis Hospital with burns to her face, chest, back, arms and legs. In spite of

Circus fire victims Dorothy Kuhnly and her daughter Georgianna (far left) with Barry and Roberta Kuhnly, survivors of the fire. *Photo courtesy of Connecticut State Library, Hartford Circus Fire Claimant Files, RG003.*

supportive treatment, her condition worsened, and she passed away late in the evening of Sunday, July 16. Roslyn attended the circus with an aunt and two cousins visiting from New York; when the fire broke out, Roslyn helped her party out of the tent and returned to help others, ultimately at the expense of her own life.

Mrs. Dorothy (Burke) Kuhnly of Rockville, Connecticut, was born on March 23, 1908, in Elizabeth, New Jersey, and was found dead at the circus grounds after the fire with her daughter Miss Georgianna May Kuhnly, twelve, who was found seriously injured. Georgianna, an active junior member of the Red Cross, was admitted to Municipal Hospital for supportive treatment and plasma transfusions, but despite the efforts of the hospital staff, she passed away just after noon on July 10. Dorothy, identified at the State Armory morgue as body 2121 by her brother, left her husband, a daughter and a son. Dorothy was healthy and active and had been working as a bookkeeper and clerk at Miller's Grocery. She attended the circus with her children, Georgianna, Roberta and Barry, and it is believed that either Dorothy

or Georgianna fell while exiting the burning tent, and when the other stopped to help, they were both overcome by the crowd.

Mrs. Katherine (Kaminski) Kullick of Chicago, Illinois, born on September 25, 1873 in Poland, survived the fire but died on September 30, 1944, from heart disease after suffering a heart attack on September 14 and never fully recovering. Not commonly considered a victim of the circus fire, Katherine's doctor indicated that the circus fire might have affected her previously diagnosed hypertensive heart disease. Her daughter Clara, who had lived with Katherine for the previous six years, swore that her mother was in perfect health until after the fire. Her estate was awarded $4,500 by the arbitration board, comparable to awards made to the estates of other female victims in Katherine's age range. Mrs. Kullick, predeceased by her husband, "Barney," in 1939, left nine adult children.

Miss Mary J. Kurneta, age eighteen, of Middletown, Connecticut, attended the circus with her mother, her brother, her sister and her nephews Anthony Kurneta and Raymond Erickson Jr. The group sat in reserved seating Section S to the left of the main entrance, four rows from the top and across from the center ring. When her brother Stanley noticed the fire, they hurried to the main entrance, toward the flames. Stanley pushed Frances and Elizabeth over the animal runway, but lost Mary and Raymond in the crowd. Mary was later found dead at the circus grounds, and her body was identified at the State Armory morgue by her brother-in-law. Miss Kurneta, who had been employed as an assembler at Cuno Engineering Co. in Meriden, left her parents, four brothers and three sisters.

Mrs. Sarah "Sally" (Israel) Lapuk of Cornwall Street in Hartford, born in 1904 in Poland, was found seriously injured at the circus grounds after the fire with her son Seymour Jerome Lapuk, eight, who was found dead on scene and later identified at the State Armory morgue as body 1537 by his father. Sarah was admitted for treatment to Municipal Hospital, where, despite supportive efforts of the hospital staff, she passed away during the afternoon of July 9. She was buried at the Barbour Street Cemetery. Mrs. Lapuk left her husband, David, and their thirteen-year-old son, Marvin, who survived the circus fire.

Mrs. Marion R. (Blanchard) LeVasseur of Bristol, Connecticut, born on September 3, 1912, in Providence, Rhode Island, was found dead at the

circus grounds after the fire and was later identified as body 1548 at the State Armory morgue by her husband, Ludger. In addition to her husband, Mrs. LeVasseur left her six-year-old son, Gerald, who miraculously survived the fire despite severe injuries, and three brothers in the U.S. Navy, one of whom was killed in action in the South Pacific while serving his country. Marion, a registered nurse, attended the circus with her son, who was seriously burned, and some friends, who all escaped relatively unscathed.

Mrs. Viola Ann (Wickham) Locke, age forty, and her daughter, Miss Elaine Ida Locke, age six, of East Hartford were found dead at the circus grounds after the fire. Viola's brother identified bodies 4507 and 1535 at the State Armory morgue on July 7, and a ring was found on Mrs. Locke's body. In addition to her husband, Viola left her fourteen-year-old son Lawrence, who attended the circus with the group and was able to escape with his life. Viola's niece and nephew, Edith W. and Joseph C. Budrick Jr., were also victims of the fire, and her sister, Edith May Budrick, was also presumed to have died in the fire, though her body was never identified.

Miss Sandra Louise Logan, age four, of Middletown, Connecticut, was found dead at the circus grounds after the fire and later identified as body 2187 at the State Armory morgue by her father. Sandra attended the circus with her mother and grandmother and fell from her mother's arms as they struggled to get out of the burning tent. She was trampled and burned, while the others escaped.

Mrs. Stephanie F. "Stella" (Strong) Marcovicz, age thirty-one, and her son Francis Joseph "Frankie" Marcovicz Jr., four, of Morris Street in Hartford were found dead at the circus grounds after the fire and were later identified at the State Armory morgue as bodies 1517 and 1525 by a relative. Stephanie's watch, a ring and her wedding ring were found on her body.

Martin "Max" Marcus of Baltimore Street in Hartford, born on January 4, 1900, in Romania, was found dead at the circus grounds after the fire. Body 4555 at the State Armory morgue, previously identified as Stanley Leonard of Simsbury but returned when Mr. Leonard was discovered to be alive, was identified as Mr. Marcus by his brother-in-law and a doctor on July 7. Max, president and director of the Atlas Cleaning and Dyeing Company in Hartford, had chronic tuberculosis from which he was showing improvement and had recently returned to duties with the company. He left his wife and two sons.

Above, left: Sandra Louise Logan, four, victim of the circus fire. *Photo courtesy of Connecticut State Library, Hartford Circus Fire Claimant Files, RG003.*

Above, right: Francis J. Marcovicz Jr., four, victim of the circus fire. *Photo courtesy of Connecticut State Library, Hartford Circus Fire Claimant Files, RG003.*

Left: Martin "Max" Marcus, victim of the circus fire. *Photo courtesy of Connecticut State Library, Hartford Circus Fire Claimant Files, RG003.*

Mrs. Marcia May (McKinney) Mason, age thirty-five, and her son, Jarvis Woolverton Mason III, three, of West Hartford were both found seriously injured at the circus grounds after the fire and admitted to Municipal Hospital. Jarvis died later that night, and Mrs. Mason was transferred on the evening of July 7 to Hartford Hospital, where treatment continued until she passed away late in the afternoon of July 12. In addition to her husband, Marcia left their five-year-old daughter, Marna May, who was injured in the fire and survived after two weeks at Hartford Hospital.

Circus fire victims Lola Mather and her daughter, Sarah. *Photo courtesy of Connecticut State Library, Hartford Circus Fire Claimant Files, RG003.*

Mrs. Lola May (Booth) Mather, age forty-one, of Ashley Street in Hartford was found dead at the circus grounds after the fire, and her daughter, Miss Sarah Elizabeth Mather, seven, was found seriously burned at the site. Sarah was taken for treatment to Municipal Hospital, where she died later that evening, and Lola was identified as body 2112 at the State Armory morgue by her father. Mrs. Mather's late husband, Edward, was a victim of drowning in 1937, and Sarah was their only child. The circus fire also claimed the life of Lola's mother and Sarah's grandmother, Sarah Booth. Lola, who had been employed as a timekeeper at Pratt and Whitney, was wearing a sling on her arm from an injury from a fall a month earlier.

Mrs. Theresa E. (Cerasale) Matteson, age forty-six, of Meriden, Connecticut, was found seriously injured at the circus grounds after the fire and was taken to Municipal Hospital, where, despite treatment, she died from her injuries later that evening. Mrs. Matteson left her husband,

Charlotte Mearman, seven, victim of the fire. *Photo courtesy of Connecticut State Library, Hartford Circus Fire Claimant Files, RG003.*

Howard Matteson, who was injured in the circus fire, and two daughters.

Mrs. Dorothy Celina (Scott) Matthews, age thirty-four, and her daughter, Miss Roslyn Matthews, five, of Rocky Hill, Connecticut, were both found dead at the circus grounds after the fire. Mrs. Matthews left her husband and their eleven-year-old son, Richard. A family friend identified bodies 1582 and 1505 as Dorothy and Roslyn at the State Armory morgue.

Miss Charlotte Caroline Mearman, age seven, of Franklin Avenue in Hartford was found injured at the circus grounds after the fire and was brought to Municipal Hospital, where she died from her injuries later that day. Charlotte left her parents.

Miss Marjorie Rose Metcalf, age fifty-one, of Rockville, Connecticut, was found dead at the circus grounds after the fire and was later identified at the State Armory morgue as body 4509 by her brother. Marjorie left two brothers, Dr. E. Harrison Metcalf and Dr. Martin V.B. Metcalf, and a niece, Virginia Metcalf, who attended the circus with Marjorie and survived, though she received burns on her arms. Marjorie was a pharmacist and owner/ proprietor of one of Rockville's oldest businesses, Metcalf's drugstore, established in 1884, which she took over after her father's death in 1927. Marjorie's brothers took ownership of the store after her death, and the business was sold in 1948.

Miss Monica Miles of East Haddam, Connecticut, born on July 7, 1938, in New York City, was found seriously injured at the circus grounds after the fire and admitted to Municipal Hospital. Despite supportive treatment, Monica died on her sixth birthday and was buried at the Little Haddam Cemetery. She left her parents; her ten-year-old sister, Audrey; and her seven-year-old brother, Willard. The Miles children were taken to the circus by their aunt Edith Walters as a birthday gift for Monica. When the fire began to rage,

Audrey and Willard ran ahead and escaped under the sidewall of the tent, while Edith struggled unsuccessfully to escape with Monica.

Stephen Ronald Milliken, age six, of West Hartford was found dead at the circus grounds after the fire and later identified as body 1541 at the State Armory morgue by a dentist. Stephen, a student at Edward Morley School in West Hartford, left his parents and his sister. He attended the circus with the Wakeman family, of which mother Virginia and son Bruce died while father Elwyn and daughter Sandra were survivors with minor injuries.

Mrs. Martha Ann (Cavill) Moore of West Hartford, born on July 7, 1879, in England, was found injured at the circus grounds after the fire and immediately hospitalized. After nearly a month of treatment, she was recovering well until she became infected and died from septicemia late in the evening of August 3 at Hartford Hospital. Mrs. Moore left her husband, Walter; two daughters; and a son. She attended the circus with her daughter Mae Avery and granddaughter Sandra, who both lived with Martha, and another granddaughter, Janet Moore, all of whom survived.

Walter D. "Brick" Murphy, age thirty-four, and his son Charles Walter Murphy, three, of Plainville, Connecticut, were found dead at the circus grounds after the fire and were later identified as bodies 2166 and 1520 at the State Armory morgue by Charles's grandfather. Walter left his five-year-old daughter Patricia, one of the most severely burned survivors of the circus fire; his infant son, James, who did not go to the circus with his family; and his sister and two brothers, one of whom was initially given custody of the surviving Murphy children until his own death in 1946 after a brief illness. Walter's wife, Mrs. Hortense (Coughlan) Murphy, thirty-two, was found critically injured at the circus grounds after the fire and was admitted to Municipal Hospital, where she died just before 1:00 a.m. on July 8. Mrs. Murphy left her parents, who ultimately became the guardians of the surviving Murphy children after years of legal battles. The Murphy family attended the circus with friends from Plainville Esther Berube and her daughter, Ann, and only Esther and Patricia survived. Mr. Murphy had been employed as an assistant pharmacist at the Liggett Drug Company and participated in the operation of Brick's Restaurant in Plainville with his brother John. Walter's family was also associated with Murphy's Alleys, a bowling establishment once located on Whiting Street in Plainville.

Miss Valerie Jane Nogas of Wethersfield, born on July 12, 1935, in Hartford was found dead with her grandmother Katherine Vensas at the circus grounds after the fire. Miss Nogas, identified by her father as body 1504 at the State Armory morgue, left her parents and no siblings.

Miss Emma "Agnes" Norris of Middletown, Connecticut, born on July 17, 1937, in Hartford, was found critically injured at the circus grounds after the fire and was taken for treatment to Municipal Hospital, where she died that evening. Her sister, Julia Ann "Judy" Norris, six, was also assumed to have died, though her body was never identified. Their aunt Elizabeth Holden, accompanied by a dentist, viewed the bodies at the State Armory morgue and insisted that Judy was not among them. The girls' parents, Michael and Eva Norris, were also victims of the circus fire.

Michael Edward Norris, age fifty, and his wife, Mrs. Eva C. (Lathrop) Norris, forty-three, of Middletown, Connecticut, were found dead at the circus grounds after the fire. Their bodies, 1551 and 4540, went unclaimed at the State Armory morgue and were removed to the Hartford Hospital morgue, where a dentist identified them as Michael and Eva on July 8, one day after Hartford police removed Michael's 1941 Oldsmobile sedan from the vicinity of Barbour Street. Michael and Eva attended the circus with their daughters, Judy and Agnes, and family friends Mrs. Mae Smith and her daughters, Barbara and Mary Kay; only the Smith members of the party survived. Before her marriage, Eva was a teacher at South School in Manchester for twelve years. Michael was employed at the Russell Manufacturing Company in Middletown.

Mrs. Irene (Cook) North, age forty-nine, and her daughter, Miss Irene Mary North, seven, of Rockville, Connecticut, were found dead at the circus grounds after the fire. Henry North identified bodies 1550 and 1540 at the State Armory morgue as his wife and daughter later that evening. On the body of Miss North was found a Gruen wristwatch and a black cord, which was turned over to the coroner's office and determined to have belonged to Minnie Hess, also a victim of the circus fire.

Daniel O'Brien, age seven, of Manchester, Connecticut, was found dead at the circus grounds after the fire and later identified as body 1512 at the State Armory morgue by his uncle. A small amount of cash was found on the body. Daniel left his father and his grandmother, with whom he had

lived since the death of his mother two years earlier at age twenty-seven. Daniel attended the circus with Terry and Betty Rester; their sister, Mrs. Mary Franz; and her son, William. All were victims of the fire.

Mrs. Eveline Y. (Breault) O'Connell, age thirty-two, and her daughter, Miss Doris Jean O'Connell, four, of Unionville, Connecticut, were found dead at the circus grounds after the fire. Dr. Enos J. O'Connell identified bodies 1552 and 1600 at the State Armory morgue as his wife and daughter on July 6. In addition to her husband, Mrs. O'Connell left their six-year-old son, Robert. Dr. O'Connell's aunt Annie Burns also was a victim of the fire.

Mrs. Mary J. (Crowe) O'Connor, age sixty-four, of 48 Tremont Street in Hartford was found dead at the circus grounds after the fire and was later identified as body 2118 at the State Armory morgue by her son. She left her husband, retired Hartford police officer Thomas F. O'Connor, and two sons, Hartford police commissioner Thomas F. O'Connor Jr. and Hartford Fire Department lieutenant John J. O'Connor.

Miss Constance Louise Pellens, age two, of New Park Avenue in Hartford was found dead with her grandmother Helen Johnson at the circus grounds after the fire and was later identified at the State Armory morgue by her father. Miss Pellens left her parents and her maternal grandfather.

Mrs. Carmela Marabella "Mollie" (Pastorello) Pistorio, age thirty-nine, of Elmer Street in Hartford was found dead at the circus grounds after the fire and was later identified as body 2120 at the State Armory morgue by her son. Mrs. Pistorio—who attended the circus with Anna DiMartino, who was also killed—left her husband and three sons.

Mrs. Lillian Lina (Roth) Poglitsch, age thirty-six, of New Britain, Connecticut, was found dead at the circus grounds after the fire and later identified as body 2113 at the State Armory morgue by her husband, Dr. Frank Poglitsch. Their son, Frank Ferdinand Poglitsch Jr., six, was found seriously injured at the circus grounds after the fire and admitted to Municipal Hospital, where, despite supportive treatment, he died after 2:00 a.m. on July 10. Lillian, a college graduate and a registered nurse, could speak several languages fluently. The Poglitsches had previously lost an infant son in 1940, and in 1956, New Britain osteopathologist Dr. Frank Poglitsch again suffered the

Circus fire victims Eva Prost and her daughter Rochelle (right) with Barbara Prost (left), survivor of the fire. *Photo courtesy of Connecticut State Library, Hartford Circus Fire Claimant Files, RG003.*

Elizabeth Putnam and her daughter Mary, both victims of the circus fire. *Photo courtesy of Connecticut State Library, Hartford Circus Fire Claimant Files, RG003.*

loss of a child when his seven-year-old daughter from his second marriage died from an illness.

Mrs. Eva (Glick) Prost, age twenty-five, and her daughter Miss Rochelle Helene Prost, three, of Capen Street in Hartford were found dead at the circus grounds after the fire. Saul Prost identified bodies 2110 and 1538 at the State Armory morgue as his wife and daughter. Mrs. Prost left another daughter, two-year-old Barbara.

Mrs. Elizabeth B. (Hamilton) Putnam, born on April 17, 1900, in Scotland, and her daughter Miss

Mary Spencer Putnam, age nine, both of Mansfield, Connecticut, were found dead at the circus grounds after the fire and identified as bodies 1575 and 1530 at the State Armory morgue later that evening. Elizabeth left her husband, University of Connecticut professor of farm management and State Farm Labor supervisor Paul Lee Putnam, and two teenaged daughters. Elizabeth was a graduate of Hartford High School and a 1924 graduate of the University of Connecticut. She worked as a home economics instructor at the University of Connecticut until 1928, when she became a mother and devoted her time to taking care of her home and family. She was active in many community groups, including the Girl Scouts. Her eldest daughter, also named Elizabeth, was said to have had a premonition while working in the tobacco fields on the day of the fire that something bad had happened to her mother. Mrs. Putnam and her daughter attended the circus with Edwin and Lucille Woodward, their grandson Peter Hines and friend Edith Corttis, all of whom were victims of the fire.

Miss Rose Theresa "Terry" Rester, age twenty-seven, and her sister Miss Elizabeth "Betty" Rester, age twenty-four, of South Coventry, Connecticut, were found dead at the circus grounds after the fire. John Rester identified bodies 1578 and 1574 at the State Armory morgue as his daughters on July 7. The girls' older sister, Mrs. Mary Franz, and their nephew, Billy Franz, were also victims of the fire. Terry had been employed at Pratt and Whitney in East Hartford, and Betty had worked at Colt Firearms in Hartford. They left their parents and three brothers.

Mrs. Elizabeth (Greenlaw) Roberts of Winsted, Connecticut, was born on June 5, 1907, in Eastport, Maine. She was found at the circus grounds with severe burns on most of her body and in shock. She was admitted to Municipal Hospital, where she passed away around midnight. Elizabeth left her husband and three children; the Roberts family attended the circus together and all of them suffered burns requiring hospitalization, with the children's injuries being less severe than those of their parents. Elizabeth had previously taught at the Forde School in Robertsville and had most recently spent her time taking care of her home and assisting her husband with his poultry business, C.S. Roberts & Son.

Mrs. Clara E. "Evelyn" (Crocker) Sartori, age thirty-nine, of East Hartford fell down the steps while escaping the circus tent, injuring her back, and suffered from nervous shock. Evelyn, who had been in fair health and

suffering from heart disease for several years, is not commonly considered a victim of the circus fire, but her doctor believed that her injuries might have aggravated her preexisting heart disease. She died at her home on February 21, 1945, from a cerebral embolism due to her rheumatic heart. Mrs. Sartori, a housewife, left her husband, their daughter and their three sons. Evelyn's husband and son Michael also attended the circus and escaped with minor injuries. Her estate was awarded $7,500 by the arbitration board, comparable to awards made to other women near Evelyn's age who received death settlements.

Miss Doris Marie Schinkel of Manchester, Connecticut, born on July 15, 1922, in Albany, New York, was found injured at the circus grounds after the fire and immediately hospitalized. Despite supportive treatment, Doris, a known diabetic, passed away after 2:00 a.m. on July 9 at Hartford Hospital from second- and third-degree burns, pulmonary edema, tracheitis and diabetes mellitus. Miss Schinkel, who had just graduated in May from Boston University with a bachelor's degree in practical arts, attended the circus with a neighbor's daughter, Miss Ellen Edson, who was also a victim of the fire. She left her parents and her sister.

Miss Joan Lee Smith, age five, of Bloomfield, Connecticut, was found dead at the circus grounds after the fire and later identified as body 1534 at the State Armory morgue by her father, attorney Edward Smith. Joan left her parents, two sets of grandparents and her nine-year-old brother, Edward Jr.

Mrs. Thyra Maria Constance (Ekholm) Smith of Canton, Connecticut, born on September 13, 1895, in Sweden was found dead at the circus grounds after the fire and later identified as body 2119 at the State Armory morgue by her son. Thyra attended the circus with a friend, who was critically burned but survived, and her niece, who escaped without injury. Mrs. Smith left three sons; her husband, Harold, died a year earlier, on July 7, 1943.

Edwin Ralph Snelgrove, age forty-eight, and his wife, Mrs. Olive M. (Rogers) Snelgrove, forty-two, of Plainville, Connecticut, were found dead at the circus grounds after the fire and were later identified as bodies 1566 and 1589 at the State Armory morgue by a Plainville dentist. Edwin and Olive's only daughter, Shirley, attended the circus with her parents to celebrate her twelfth birthday, which was that day, and was seriously injured. The Snelgrove family sat opposite of where the fire started, and they rushed to the top of bleachers

Edwin, Shirley and Olive Snelgrove were celebrating Shirley's thirteenth birthday at the circus. Only Shirley survived the fire. *Photo courtesy of Connecticut State Library, Hartford Circus Fire Claimant Files, RG003.*

when the tent ignited; however, they feared the twelve-foot drop and headed toward the exit. Shirley became separated from her parents at the animal runways and decided to return to the top of the bleachers. This time, she jumped and was dragged outside to safety. Her parents remained inside the tent when the roof collapsed. Edwin, most recently employed as an assistant secretary at Adkins Printing Company in New Britain, had worked as an assistant treasurer for Commercial Trust Company in New Britain as a young man in 1924 and was involved in an embezzlement scheme to which he and others confessed. Two days after Edwin married Olive, he was arrested, and the warrant for his arrest was served by Hartford County detective Edward J. Hickey, who served as the state police commissioner in 1944 during the circus fire tragedy and was also in attendance at the circus that day. Also in the circus audience on July 6, 1944, was Hugh M. Alcorn, who, in 1924, was the state's attorney who prosecuted Mr. Snelgrove in the embezzlement case. Each of the defendants was found guilty and sentenced to three to five years in prison.

Louis Steinberg of Sigourney Street in Hartford, born in 1870 in Russia, was found dead at the circus grounds after the fire and was later identified as body 1544 at the State Armory morgue by his son Samuel. Louis, a retired merchant in Hartford for over forty years, left two sons and four daughters and was predeceased by two wives; his first wife and mother of his children, Molly, died in 1931, and his second wife, Ida, passed away in July 1943.

Mrs. Katherine L. "Katie" (Pulver) Surdam, age sixty-one, of New Hartford was found dead at the circus grounds after the fire and later identified as body 2161 at the State Armory morgue by a relative. Katherine's late husband Frederick Surdam Jr. died in 1933, and their son Clarence Surdam, twenty-eight, was found at the circus grounds after the fire with extensive burns to most of his upper body. In extreme pain and burn shock, Clarence was admitted to Municipal Hospital and treated with plasma and morphine until July 7, when he became irrational and then comatose. He passed away later that night. Prior to his death, Clarence ran a chicken farm in the New Hartford area, with which his mother, Katie, helped. Hartford policemen removed Clarence's car, a '38 Chevy Suburban, from the area around the circus grounds the day after the fire. Mrs. Surdam, who left her son Earl Pulver, was in very good health and wore a brace for a double hernia condition that she suffered at age thirteen.

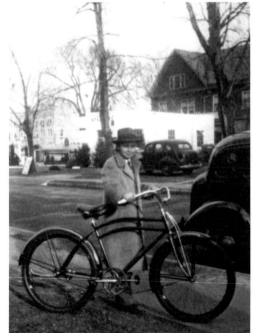

Vincent Testa of Garden Street in Hartford, born on January 10, 1934, in Kansas City, Missouri, was found dead at the circus grounds after the fire and later identified at the State Armory morgue by his father and an uncle. Vincent left his parents, Sam and Laura, who met when Sam came to Hartford as a racecar driver in the 1930s. They

Vincent Testa, ten, victim of the circus fire. *Photo courtesy of Connecticut State Library, Hartford Circus Fire Claimant Files, RG003.*

never fully recovered from the loss of their only son and only child at the time. Vincent attended the circus with his cousin Jerome Montano, aunt Amy Montano, aunt Ella Russo, aunt and uncle Rose and Frank Sullivan and cousins Dennis and Eileen Sullivan, and he was the only one of the group to be fatally injured.

Mrs. Anna Marie Euphissyne (Sahlin) Thompson, age forty-seven, of Bristol, Connecticut, was burned in the circus fire over 28 percent of her body, particularly on her neck, back and arms, and was taken to Municipal Hospital immediately after the disaster. Stabilized and sedated with morphine, she was moved on July 8 to Hartford Hospital, where she remained until September 11. Treatment for her burns and for emotional distress from the fire and a split with husband Robert Thompson continued in the following months at Bristol Hospital until her death from an embolism following an operation in July 1945. Mrs. Thompson left her daughter, Judith Doyle, eleven, from her late first husband, and her brother, Morris F. Sahlin, who became the guardian of Judith. Miss Doyle attended the circus with her mother and was burned on her forehead, shoulder, elbows and scalp; her burns were less severe than her mother's, and she was treated at and then released from the hospital. Anna had been employed at Bristol Savings Bank for several years, and was in good health with no ailments. The injuries she received from the circus fire left her partially disabled after her discharge from Hartford Hospital. Though not commonly considered a victim of the circus fire, Mrs. Thompson's estate was awarded $7,500 by the arbitration board, comparable to awards made to the estates of other women in her age group who died in the fire. Arbitrators questioned whether Anna's death was caused by the fire but decided that her estate would be entitled to the award based on her injuries alone and did not dispute the claim.

Charles Tomalonis of Lawrence Street in Hartford, born on February 15, 1897, in Lithuania, attended the circus with Mrs. Katherine Vensas and her granddaughter, Valerie Nogas, and all of them lost their lives in the fire. Mr. Tomalonis was found seriously injured at the circus grounds after the fire and was taken for treatment to Municipal Hospital, where he died during the evening of July 11. Charles, a tobacco farm worker for Imperial Agricultural Corp. was a longtime boarder in the home of Mrs. Katherine Vensas, and in 1935, he bequeathed his entire estate to her. Mrs. Vensas, however, was also a victim of the circus fire, leaving Mr. Tomalonis with no known heirs. After a mandatory ten-year waiting

period, his estate (then valued at $7,775.34) was closed in 1958, and the money was turned over to the State of Connecticut.

Miss Joan Frances Toth, born on July 3, 1935, in New York City, of Woodbine Street in Hartford was found dead at the circus grounds after the fire and later identified as body 1533 at the State Armory morgue by her father. Joan's sister, Miss Regina Dianne Toth, born on July 1, 1933, in New York City, was found seriously injured at the circus grounds after the fire and died soon after being admitted to Municipal Hospital. The girls were celebrating their birthdays at the circus with their mother, Louise, and their brother, Albert. All of them were severely burned, and only Louise and Albert survived. Louise was in a coma for some time after the fire and wasn't aware that her daughters had died until months later. The girls' father, Alexander, was employed as a supervisor at Pratt and Whitney.

Mrs. Laura Josephine (LeClair) Traver of Bloomfield, Connecticut, born on January 30, 1905, in Vermont was found at the circus grounds after the

fire with second- and third-degree burns and taken to Municipal Hospital, where she was treated with plasma, dressings and morphine. Unable to retain fluids, Laura died after 2:00 p.m. on July 9 from toxic glomerulonephritis with renal failure. Mrs. Traver left her husband, Harry, and no children.

Anna Venberg, fifty-two, victim of the circus fire. *Photo courtesy of Connecticut State Library, Hartford Circus Fire Claimant Files, RG003.*

Miss Anna Linnea Venberg, age fifty-two, of New Britain, Connecticut, was found dead at the circus grounds after the fire and was later identified as body 4511 at the State Armory morgue by her brothers Conrad and George. Miss Venberg, employed as an inspector at Fafnir Bearing in New Britain, attended the circus with her nephews, who were able to escape

the burning tent. Anna left her father and four brothers, all of New Britain.

Mrs. Katherine (Juskauskas) Vensas of Lawrence Street in Hartford, born on April 11, 1883, in Lithuania, was found dead at the circus grounds after the fire and was identified as body 1572 at the State Armory morgue by her son-in-law on July 6 and confirmed by her daughter on July 7. She left two daughters and three sons and was predeceased by her husband, Vincent Vensas, whom she married at age seventeen. Mrs. Vensas attended the circus with her granddaughter

Elizabeth de la Vergne, thirty-three, victim of the circus fire. *Photo courtesy of David de la Vergne.*

Valerie Nogas and a roommate, Charles Tomalonis, and all three died from their injuries.

Mrs. Elizabeth M. "Beth" (O'Brien) de la Vergne of Meriden, Connecticut, was born on November 17, 1910, in Meriden, graduated from the College of St. Elizabeth in New Jersey and worked until her marriage to Dr. Paul Mason de la Vergne. She was an active member of many clubs and groups, including the executive committee of the Red Cross. Elizabeth, her husband and their four-year-old son, David, went to the circus with friends from Undercliff Sanitorium in Meriden: Dr. Lawrence Thompson and his son, Jack. Dr. Thompson had acquired five tickets, and his wife offered to stay home and watch the Vergnes' infant son, Thomas, so Elizabeth could attend the show. At the circus, the group sat in the top row of bleachers, but Elizabeth relocated to a lower seat due to her fear of heights; she turned and waved to her son David from her seat below. The men escaped the burning tent by dropping the boys down behind the bleachers and

sliding down the ropes after them. Elizabeth did not make it out alive and was identified by Dr. Thompson later that day as body 4502 at the State Armory morgue.

Mrs. Ida (Kachelries) Verret of Main Street in Hartford, born on October 6, 1908, in Shamokin, Pennsylvania, was found dead at the circus grounds after the fire and was later identified as body 2171 at the State Armory morgue by her husband, Frederick. In addition to her husband, Ida left her daughter, Joan, eight, and son Frederick Jr., five, who both attended the circus with their mother and survived. Frederick, who worked for the War Production Board in Mount Washington, Pennsylvania, had recently transferred to Hartford, and his wife and children moved to the area with him. His sister Myrtle Verret was visiting them in Hartford at the time and was also a victim of the fire.

Miss Myrtle Verret, age twenty-two, of Pittsburgh, Pennsylvania, was found dead at the circus grounds after the fire and later identified as body 1516 at the State Armory morgue by her uncle. Myrtle, employed as a cashier at General Public Corp., had flown from Pennsylvania to Hartford earlier in the week to spend her vacation with her brother Frederick and his family. She went to the circus with Frederick's wife, Ida, and his children, Joan and Frederick Jr., and only the children survived.

Mrs. Mildred Rita "Millie" (Jacques) Viering, age twenty-seven, and her son, Paul Oliver Viering, four, of Victoria Road in Hartford were found dead at the circus grounds after the fire. Joseph Viering, a member of the Hartford Fire Department, identified bodies 1584 and 1527 at the State Armory morgue as his wife and son. Mildred and her son, Paul, attended the circus with her sister-in-law Theresa (Viering) Franz and her husband, Richard Franz Sr., and their son Richard Jr. Theresa and Richard Jr. sat with Mildred and Paul in the reserved seating area until an usher made them move to their own seats in the bleacher section. Moments later, the fire began behind the area where Mildred and Paul were seated. The Franzes escaped without serious injury.

Mrs. Anna Christina (Seitz) Wabrek, age forty-five, of New Hartford was found seriously injured at the circus grounds after the fire and was taken to Municipal Hospital, where she died during the morning of July 8 despite supportive efforts to save her life. Mrs. Wabrek's daughter, Miss Lorraine T. Wabrek, thirteen, was also a victim of the fire found dead on the scene and

identified as body 1518 at the State Armory morgue by her father; on her body was found a watch and a ring. In addition to her husband, Mrs. Wabrek left two sons: Waldemar, nineteen, and Frederick, twenty-five, whose niece Mary Bedore also died in the fire.

Mrs. Anna Barbara Waichen of Manchester, Connecticut, was born in 1882 in Lithuania and immigrated to the United States in 1913 with her husband and son. She was found dead at the circus grounds after the fire and was later identified as body 4508 at the State Armory morgue by her son-in-law. On her body was found a ring and a wedding ring. Mrs. Waichen left her son, Joseph, and three daughters, Nellie, Ella and Sylvia. Nellie and Sylvia accompanied Anna to the circus and were able to escape. It was reported that in 1930, Anna's husband set the family home on fire, left the house and took his own life by hanging. Her son, Joseph, carried Anna, ill and bedridden at the time, out of the house. Daughter Nellie was also in the house and was able to escape without harm.

Mrs. Virginia (Thomson) Wakeman, age thirty-three, and her son, Bruce Carlyle Wakeman, seven, of West Hartford were found dead at the circus grounds after the fire. Elwyn D. Wakeman identified bodies 2103 and 1502 as his wife and son at the State Armory morgue, and on his wife's body was found a ring. In addition to her husband, Virginia left her three-year-old daughter, Sandra. The Wakeman family—Virginia, Elwyn, Bruce and Sandra—attended the circus together, along with Bruce's friend Stephen Milliken; only Elwyn and Sandra survived the inferno. Mrs. Wakeman was a 1928 graduate of Hall High School, studied at the Springfield Library School and spent several years on staff at the Mark Twain Branch of the Hartford Public Library.

Miss Edith Alice Walters, age twenty-two, of East Haddam, Connecticut, was found with broken ankles and severe burns at the circus grounds after the fire and admitted to Municipal Hospital. Despite supportive treatment, Miss Walters died during the morning of July 7. She left her parents, her brother and two sisters and was predeceased by another brother, who was killed in a motor vehicle accident as a teenager in 1934. Edith, a 1941 graduate of Nathan Hale High School, was an excellent bowler and an ardent baseball fan. She took her sister's children, Audrey, Willard and Monica Miles, to the circus as a birthday gift for Monica. When the tent caught fire, Audrey and Willard ran ahead and escaped

under the sidewall while Edith struggled to escape with Monica. Both suffered fatal injuries.

Mr. Edwin Garver Woodward of Salisbury, Connecticut, born on April 7, 1890, in Missouri, was found seriously injured at the circus grounds after the fire and was admitted to Municipal Hospital for supportive treatment. Despite the efforts of the hospital staff, Mr. Woodward passed away at 10:00 p.m. on July 7. His wife, Lucille Auletta (Matthews) Woodward, age sixty, was assumed to have also died in the circus fire, though her body was never identified. Edwin and Lucille attended the circus with their grandson Peter Hines, their friends Edith Corttis and Elizabeth Putnam and Mrs. Putnam's daughter, Mary; no one in the party survived. Edwin was the dean of agriculture at the University of Connecticut in Storrs and had previously been an instructor at the University of Nebraska and the Dairy Products and Food commissioner for the state of Connecticut.

What is commonly considered victim number 168 of the circus fire, and included in the board of health's count of the deceased, was actually a mismatched collection of body parts collected from various locations at the fire scene that were not able to be matched with a victim. Dr. Weissenborn described the parts on July 10 as one left foot from a ten-year-old child; one adult left foot; one scalp with brown hair, brain attached; one adult left hand; and another adult left foot. Despite the description written by Weissenborn, the coroner's report and death certificate were filled out as if the parts belonged to a single individual that was burned and crushed at the scene. The decomposing parts were incinerated at the Hartford Hospital on July 7, without services or burial.

Five bodies found at the circus grounds after the fire and one that died in the hospital the evening of the fire were first taken to the State Armory morgue and later removed to the Hartford Hospital morgue, where they remained unidentified. The bodies were known only by their numbers—1503, 1510, 1565, 2109, 2200 and 4512—and while the bodies of six victims of the circus fire were never found, the six bodies and the six victims did not match. Considering the condition of the bodies of many of those who died, and without DNA testing, it is evident that six families, and possibly more, incorrectly identified their loved ones at the morgue.

Body 1503 was the body of a nine-year-old girl with a slender build—three feet, eleven inches tall and weighing fifty-five pounds—with light brown hair with a red glow. Her body was badly burned and her hands, feet and the top

Morgue photograph of the unidentified body of Little Miss 1565. *Photo by Bob Glynn, courtesy of Connecticut State Library, State Police Investigation Files, RG161.*

of her skull were absent. Her upper and lower permanent incisors and first molars were present, and all of her baby molars were present, with fillings in the four baby second molars.

Body 1510 was the body of an eleven-year-old boy with a muscular build—four feet, four inches tall and weighing seventy pounds. He was wearing the remnants of white shorts and undershirt and was badly burned with his feet, hands and the top of his skull all missing. Only three baby teeth were present, the upper cuspids and the lower left second molar, and there were a total of five fillings in four of his teeth.

The most publicized of the unidentified bodies, 1565, was a five to six-year-old girl, three feet, ten inches tall and weighing forty pounds. She had blue eyes and curly, light brown shoulder-length hair. She was wearing brown shoes and a flowered dress. Dental examination showed that all of her baby teeth were present except the lower central incisors, which were the only permanent teeth to have erupted. This victim, unburned and only slightly disfigured from being trampled, was taken to Municipal Hospital after the fire, where she died later that evening. "Little Miss 1565," as she would soon become known, captured the hearts of the entire country, with everyone shocked that nobody had recognized the little girl. The fact that she was not claimed led to wild speculation and theories. In 1991, the body of Little Miss 1565 was declared to be Miss Eleanor Cook by Hartford fire investigator Rick Davey, and the body was exhumed from Northwood Cemetery and buried in Southampton, Massachusetts, next to Eleanor's brother, Edward Cook.

Body 2109 was the body of a small-boned, stocky woman over thirty years old, between five feet, one inch and five feet, five inches in height and weighing 148 pounds with light brown hair, wide hips, a large bust and small hands and wrists. She was wearing pink pants, a heavy laced Spencer corset and tan socks. Dental examination showed that she had some gold crowns and fillings in her teeth, and a surgical scar on her abdomen.

Body 2200 was the body of a man aged fifty-five to sixty, five feet, three inches tall and weighing 170 pounds. His head was badly burned, and his

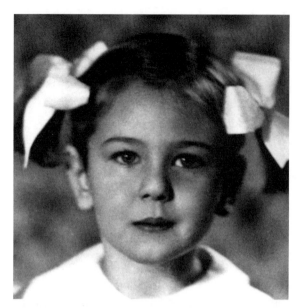

Left: Eleanor Emily Cook, eight, victim of the circus fire, declared to be Little Miss 1565 in 1991. *Photo courtesy of Connecticut State Library, State Police Investigation Files, RG161.*

Below: This engraved stone monument memorializes the unidentified victims of the circus fire at Northwood Cemetery in Wilson, Connecticut. The six unclaimed bodies were buried here in individual graves. Little Miss 1565 was exhumed in 1991 and reburied beside her brother in Southampton, Massachusetts. *Photo by author.*

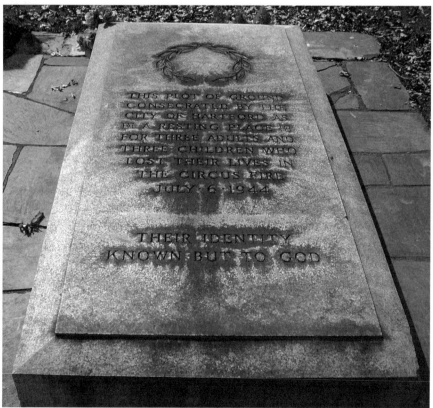

feet and hands were burned off. He showed signs of regular dental care, with extensive gold work and bridges, and he had a fractured jaw, probably from an old injury.

Body 4512 was the body of a thirty- to thirty-five-year-old woman with a short and stocky build—five feet, two inches to five feet, five inches tall and weighing 140 to 160 pounds. Every portion of this woman's skin had been burned, all of her hair was gone and her legs were mostly absent. She was wearing an ornamental ring on her right ring finger, with stones missing; a Sterling Silver slave bracelet on her left wrist; and an eighteen-karat gold wedding band on her left ring finger. Dental examination showed that her teeth were large and strong, and her upper teeth sloped forward.

A funeral was held for the six unidentified victims on July 10 at Hartford Hospital. As the hearses passed city hall, Mayor Mortensen joined the procession, and they traveled on to Northwood Cemetery for the burial of unidentified bodies 1510, 1565, 1503, 2300, 2109 and 4512. Hartford police officers and firemen served as pallbearers, and Rabbi Silverman, Father Looney and Reverend Archibald officiated to ensure that each of the unknown victims' faiths was respected.

Chapter 5
THE AFTERMATH

I was mesmerized by the fire, until I felt the heel of my shoe being tugged from below. I looked around and saw my group was gone; looked down and there was my mother motioning for me to jump down.

MARY WALLACE BUSHNELL

Hartford attorneys immediately began filing personal injury lawsuits against Ringling after the fire, working through the night and attaching the assets of the circus; Ringling would not be allowed to move any of its equipment, stock, animals or rail cars out of Connecticut. Claim amounts quickly exceeded the circus's assets that were in the state, estimated at $500,000, and nothing would be left for those who hadn't filed suits right away. To protect the rights of the injured and the estates of the dead, the Hartford bar worked together to formulate a favorable plan to allow the circus to leave Hartford. Judge John Hamilton King approved the proposed temporary receivership, with attorney Edward Rogin chosen as receiver.

Attorney Rogin would take control of the books, assets and debts of the circus, and in turn, all future circus fire-related attachments against Ringling would be prevented. All existing liens would be released, and a three-member arbitration board would review all future claims before being submitted to the receiver for payment, out of court. Ringling opposed the plan at first but eventually agreed to accept Rogin as the receiver. The circus genuinely wanted to compensate the victims of the fire, regardless of legal liability, and the receivership plan was a way for it to continue earning, which was

Circus men take a break near some charred wagons along the south side of the burned ruins of the big top, near the end where the fire started. *Photo by Robert D. Good, from author's collection.*

the only way it could possibly compensate all those who suffered losses. The receivership, and Rogin as receiver, would be made permanent in September 1944, and claimants were given until July 6, 1945, to submit their claims.

The three-member arbitration board consisted of one member each selected by the chief justice of the Connecticut Supreme court, the attorneys representing the plaintiffs and the circus. Smaller claims, those under $200, were handled directly by the circus, and all other claims were to be submitted to the arbitration board, with the appropriate affidavits. The board would review the claims and approve or deny the legitimacy and the amounts of them, since liability had already been determined. A total of 551 claims would be submitted to the arbitrators, with only 35 denied. The approved claims totaled just under $4 million, and Ringling made regular payments toward the claims, with the last of the settlements paid in full in August 1950.

With the receivership plan in place and bond of $500,000 posted by Ringling, Judge King issued an order releasing the assets of the circus, and Ringling moved its equipment to the Windsor Street rail yards before leaving the city on July 15. Several circus employees had to remain in Hartford for further questioning, but the bulk of the show began the three-day, 1,500-mile run to Sarasota, Florida. Ringling's directors had begun working on

plans for the show to return to the road in August, and props and equipment needed to be rebuilt quickly. The defendants' trials were postponed to allow them to return to Sarasota to help get the show rebuilt.

At Ringling's July 28 board of directors meeting, John Ringling North protested taking the show back on the road after the fire and was not impressed with the proposed plan to show in stadiums and ballparks for the remainder of the 1944 season. First vice-president James Haley's plan was for the show to open in Akron, Ohio, on August 4. If the circus was going to be held liable for the claims, and it surely would, the claims would exceed the show's assets. Continuing to perform would enable the circus to allocate any revenue from the shows to the future claims and would portray a positive image to the public that the circus was still strong, would continue operating and would pay the claims. If the show returned to winter quarters for the season, many of the show's expenses would still be due and payable, but there would be no incoming funds to prevent the circus's bank account from being drained. Only moderate attendance at the shows would be required to cover the expenses. The directors voted for the plan, and the show left Sarasota on July 30, headed for Akron.

After the Hartford fire, nearly all jurisdictions required fireproof tents, and exits were liberally expanded in all tented places of gathering. Local authorities began enforcing no-smoking rules, and the attention of fire marshals and inspectors was increased, especially with circuses. Shows were now required to show proof that their tops were fire resistant, or they would have to perform without them, as Ringling did when it returned to the road in August.

The Rubber Bowl in Akron, Ohio, home of the Akron Zips college football games, would host the circus's first performance after the fire. Following three days in Akron, the show continued with performances in open-air arenas and stadiums, including Michigan's University of Detroit Stadium and Soldier Field in Chicago. The show was set back by several rain-outs, and a polio quarantine hurt attendance in one city. But the second half of the tour wasn't a total failure. Ringling closed its season on October 8 at Pelican Stadium in New Orleans and returned to winter quarters in Sarasota.

Hartford's mayor in 1944, in his first and only term as mayor, was William H. Mortensen. Fifteen years earlier, after managing the construction of its new building, he became managing director of the Horace Bushnell Memorial Hall, a landmark in Hartford to this day. Bushnell Hall brought the arts and culture to Hartford, and Mortensen would remain as director

Mayor Mortensen hands a toy to Robert Hopkins Jr., five, hospitalized with burns from the circus fire. Donald MacRae, twelve, observing, escaped the fire without injury. *Hartford Courant photo, courtesy of Connecticut State Library, State Police Investigation Files, RG161.*

until his retirement in 1968, throughout a long career of philanthropy and one term each as state senator and mayor of Hartford. Mortensen rushed to the Barbour Street grounds shortly after the fire, having been alerted to the disaster by a reporter who brought him to the scene. The mayor of Hartford helped with the rescue efforts at the scene and toured Municipal Hospital, heartbroken by the scene that was before him. Mortensen appointed a board of inquiry to investigate the circus fire and report back to him and the common council on how the city officials and employees performed under the circumstances. The board was expected to review ordinances and regulations, conduct interviews and thoroughly investigate each aspect of the city's involvement before, during and after the disaster. It was to be harsh with its criticism, if applicable. The board spent two months with its investigation and released its report on November 17, 1944.

The board studied and reviewed the process by which the circus acquired the licenses for using the lot and how each of the city's departments performed. Response by the Hartford Police and Fire

Departments after the fire was applauded, as was the coordinated effort of all city departments involved in the efforts after the fire. The board criticized communication between the city departments, noting that there was no coordination between them before the fire. The licenses that the circus paid for afforded it no protection or consideration by the departments issuing them, aside from use of the space. Since no rules or ordinances appear to have been broken, the board suggested immediate legislation to correct the problems and offered suggestions for improving communications, as well as ways to prevent another tragedy from happening on city-owned property.

Also in November 1944, Hartford's board of health collected information from the hospitals and reported the casualty numbers: 168 dead, including the collection of parts, and an additional 484 persons injured. Of the injured survivors, 140 required hospitalization, with Hartford Hospital, Municipal Hospital and St. Francis providing the required care for a majority of the injured. In addition to burns and smoke inhalation, casualties suffered a variety of injuries, including friction burns from sliding down ropes and poles; fractures, sprains and strains; contusions; and emotional distress. Dozens of Ringling employees were injured, none seriously and none killed, and most sought treatment from the circus's traveling doctor rather than seeking care at the Hartford hospitals. Few felt welcome outside the confines of the circus grounds, with public scorn for the circus beginning to develop.

The coroner for Hartford County, Frank E. Healy, held an inquest into the deaths of those at the circus fire. He reviewed evidence and photographs and interviewed circus personnel, city officials and employees, patrons of the circus and other witnesses. His report, released on January 11, 1945, was critical of the circus employees and their practices. Coroner Healy found Ringling men James Haley, George Smith, Edward Versteeg and David Blanchfield, as well as seat men William Caley and Samuel Clark, guilty of reckless conduct. The seat men were noted as being under the bleachers when the fire started, but after further review of the testimonies, charges against Clark were dropped. The coroner charged Aylesworth for deserting his post without leaving anyone in charge of the seat men, and Versteeg was charged for not properly distributing the fire extinguishers. Haley's and Smith's charges were for being the men in charge on the circus grounds. President Robert Ringling wasn't in Hartford on July 6, allowing him to avoid being held responsible.

State police commissioner Edward J. Hickey, as the state's fire marshal, investigated the fire and released his report to the state's attorney, also

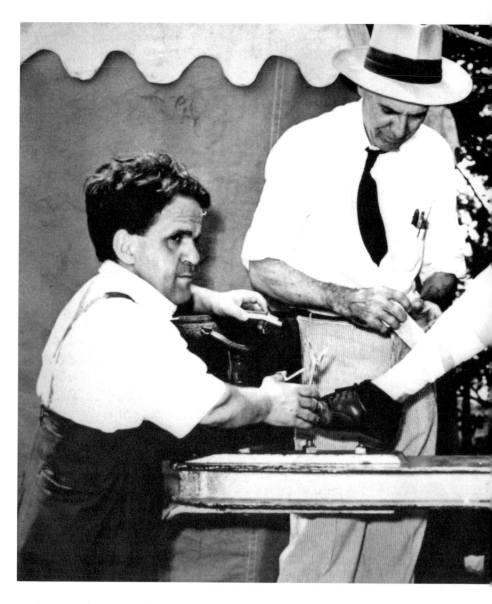

on January 11, 1945. Circus workers, city employees, policemen, firemen and patrons of the circus were among the 146 witnesses called to appear before Hickey for questioning. His report was critical of the Hartford Fire Department for not inspecting the circus grounds and not detailing any firefighters or apparatus to the scene, and reference was made to Connecticut cities Waterbury and Bridgeport, where either the fire marshal or the chief inspects the circus when it comes to town. Hickey

The circus's doctor gets some help from a circus performer to aid a man injured in the fire at the Barbour Street circus grounds in Hartford on July 6, 1944. *Photo courtesy of Connecticut State Library, State Police Investigation Files, RG 161.*

identified the origin of the fire as being in the southwest corner of the main tent, behind the blue bleachers, and his determination of the cause of the fire was an unidentified smoker who tossed a lit cigarette from the seats above, igniting the dry grass at the base of the big top sidewall and support jack. Like Officer McAuliffe's testimony about the tossed cigarette, Ringling usher and seat man Kenneth Gwinnell's and Neil Todd's testimonies resonated with Hickey; Gwinnell had testified that the only logical cause of the fire was a thrown match or cigarette, and Todd stated that he had put out dozens of fires from his post under the seats this season alone. Hickey made selective reference to both of these men's testimonies in his report, disregarding numerous testimonies to the contrary. Hickey concluded that no evidence was found, to his knowledge, to indicate that the fire was the act of an incendiary.

The commissioner's report was especially critical of the circus for its lack of fire prevention equipment, insufficient personnel to handle an emergency, allowing the exits to be blocked by the animal runways and failure to replace the men on fire watch when they were called on for other duties. Aylesworth's leaving his seat-men unsupervised while he left the circus grounds was noted in the report as a contributing factor as well. Evidence collected from the circus grounds for Hickey's investigation included two pieces of burned canvas believed to be from the sidewall; pieces of canvas from the dressing tent, menagerie and men's toilet enclosure; three burned seating jacks; and a piece of the animal runway.

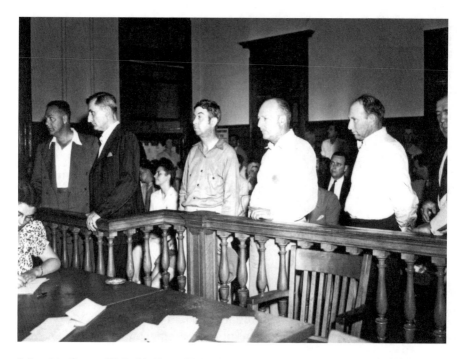

Left to right: George W. Smith, James Haley, Edward "Whitey" Versteeg, Leonard Aylesworth and David Blanchfield, all employed by the circus, accused and found liable for the loss of lives in the circus fire. *Photo courtesy of Connecticut State Library, State Police Investigation Files, RG161.*

The circus's defendants pleaded "no contest" to the charges of involuntary manslaughter against them, effectively admitting guilt, believing that any sentences imposed on them would be suspended considering that Ringling had accepted responsibility for the restitution to the victims and those who suffered. Sentences were imposed on the circus men in February 1945, and all but one was stayed until April to allow the show to prepare for the upcoming season with its key personnel.

In March 1945, Ringling attorneys sought a suspension for the sentences of those charged, appealing to the judge with a lengthy document defending each of the accusations made against the circus. Ringling argued that the human error of seat man John Cook was responsible for the fire, for deserting his post under the southwest bleachers, and that the other Ringling men were innocent of the charges against them. Judge William J. Shea denied Ringling's motion to suspend the sentences, but he did reduce them.

General manager George W. Smith and boss canvas man Leonard S. Aylesworth were sentenced to terms of two to seven years in the state prison in Wethersfield, Connecticut. Judge Shea amended the sentences to a minimum of one year and a day and a maximum of five years. Both men, critical to the operation of the circus, stayed their sentences until June 7, 1945, and were released the following February after serving the minimum time, with time off for good behavior.

James Haley, first vice-president, received a sentence of one to five years in state prison, changed by Judge Shea to the same sentence as Smith and Aylesworth. Haley began serving his sentence at the state prison in April after the show was readied for the 1945 season and was released after serving the minimum time, eight months and seventeen days.

Edward Versteeg, chief electrician, and William Caley, seat man, were sentenced to one year in county jail. Caley's sentence was the only one not stayed, and he began serving his sentence immediately. Versteeg's sentence was stayed to allow him to prepare the show for the upcoming season. He went to jail in April and was released with Caley in September. Caley, described as a model prisoner, was released for good behavior; Versteeg was released due to a medical condition. David Blanchfield, superintendent of the Trucks and Tractors Department, was sentenced to six months in county jail, which Judge Shea suspended, commending him for his honest testimony.

Of those who survived the fire, Mrs. Katherine (Reno) Martin was considered by doctors to be the most severely burned. Mrs. Martin grabbed her five-year-old daughter and nephew and ran when she saw the big top on fire, but her path was blocked by an animal runway. She got the children over the obstacle and was trying to climb over it herself when the big top collapsed on her. Formerly a dancer, she was awarded the largest settlement, $100,000, for her injuries, which consisted of severe burns to her upper and lower extremities and her back. Katherine was virtually unable to move for nearly five months and continued recovering for years. She died at age ninety-five in 2005.

Five-year-old Patty Murphy, orphaned by the fire, was said by doctors to have been the sickest of the patients. Patty received serious burns to her upper and lower extremities and suffered infections during her painful recovery, with doctors fearing she would die on July 28. She was the last of those who survived the fire to leave the hospital and received the second-largest award, $90,000. Patricia Hortense Murphy authored *LOSS: A Book for Grieving Children* in 2012.

Donald Seabury Gale was ten years old when a soldier saw the boy's hands sticking out from a pile of bodies and pulled him out. Donald's

Nurse Phyllis Willet serves ice cream to Marie Ann Connors, injured in the circus fire. *Photo courtesy of Connecticut State Library, State Police Investigation Files, RG161.*

From Municipal Hospital's chief resident Dr. Milton Fleisch's photograph collection, this image shows a patient undergoing grafting surgery for burns received in the circus fire. *Photo courtesy of Connecticut State Library, Manuscripts Collection, Dr. Milton Fleisch Collection, RG069.*

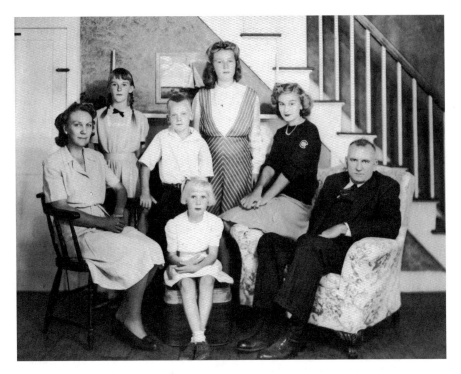

A 1944 photograph of the Wallace family, *left to right*: Nellie, ten-year old Mary, Charles, Elizabeth (front center), Cora, Dorothy and Dr. Raymond H. Wallace of Storrs, Connecticut. All but Dorothy and Dr. Wallace attended the circus and escaped from the burning tent through a slit in the sidewall canvas. Dorothy wears a patch on her shoulder, indicating that she worked in the tobacco fields for the war effort. Seventeen years after the fire, Mary married another circus fire survivor, James Bushnell, whose family attended the circus with the Wallace family. *Photo courtesy of Mary Wallace Bushnell.*

injuries led to permanent deformities to his hands, with lesser burns to his arms and head. He was awarded a $75,000 settlement, the third-largest award, for what doctors considered the worst case of permanent deformation of all those who survived the fire. Donald left college for a job as a medical photographer, a job he held until his retirement. He died at age seventy-four in 2008.

Some survivors were more fortunate than those who were burned. Ten-year-old Mary Wallace and her younger brother, Charles, represented a typical group attending the circus in 1944. Mary's mother and neighbor Elizabeth Bushnell decided to take seven of their children to the circus, a thirty-mile drive from their homes in Mansfield, Connecticut, made possible only by the ration-free tank of gas that came with a used car the

Bushnells had just purchased. The group parked at G. Fox in Hartford and took the city bus to the circus grounds. They took their seats in the bleacher section of the big top. When they noticed the fire, they jumped through the bleachers to the ground while Mary hesitated for a moment. A tug on her foot prompted her to join the others, and they all escaped through a hole cut in the sidewall canvas behind the bleachers. All of them escaped without serious injuries, though the psychological distress would continue to haunt them. One of the neighbor's sons, James Bushnell, would take Mary Wallace as his wife seventeen years after they survived the circus fire together.

A few survivors of the fire went on to achieve various degrees of celebrity status. Future star of stage, film and television Charles Nelson Reilly was thirteen years old and living on Vine Street in Hartford when he was at the circus fire and escaped under the sidewall. He never got over his reluctance to sit on the audience side in a theater.

Jan Miner was a Hartford radio show host in 1944 and attended the circus with a group of children and their teachers. Jan left the tent early in the show, unable to handle the heat, and was standing across the street when the big top went up in flames; everyone in her group was able to escape. Jan later became known for her radio drama and stage work, but her role as Madge the manicurist in the Palmolive dish soap commercials for nearly three decades made her a television icon.

In the years following the circus fire in Hartford, folks in Connecticut had to travel to Boston or New York if they wanted to see a Ringling show. For all of the circus's outdoor performances from 1945 to 1956, it used waterproofed and fire-resistant canvas and adhered to stricter requirements for exits at the expense of some seats. June 1948 marked Ringling's return to the state, with dates in Bridgeport, Waterbury, Plainville and New London.

During the early, pre-dawn hours of June 18, 1948, the Ringling Brothers and Barnum & Bailey Circus returned to Hartford County for its first time since the fire, with its trains rolling into Plainville, Connecticut, population ten thousand, one of the smallest towns the Big Show had ever visited for a performance. Local diners remained open all night for over one thousand circus fans who turned out to greet the show at the freight yard. As the sun began to rise, townsfolk, still in pajamas and slippers, left their homes and went out to the two-mile stretch of East Main Street and New Britain Avenue to catch a glimpse of the procession of animals and trucks making their way to Tinty's Ranch. Plainville's Joseph Tinty, a respected shop owner and equestrian, convinced Ringling to return to the county and welcomed

Prior to the Ringling Brothers and Barnum & Bailey performing under a new, fireproofed canvas for the 1945 season, Washington, D.C. fire marshal R.C. Roberts holds a match to the sidewall as deputy fire marshal Captain R.A. Warfield holds a stop watch, measuring the time that the canvas remains burning when the contact with the flame is removed. *Photo by Acme Photo, from author's collection.*

the circus to set up on his sixty-five-acre tract of land, which would later become Plainville Stadium, home of car races, rodeo shows, circuses and other events. To persuade the Big Show to come back to the area and play in a relatively small town, Tinty had to guarantee that the big top would be full; and indeed, it was.

Ringling played two shows in Plainville to sold-out crowds of over ten thousand at each show. While many who were in Hartford four years earlier to witness Ringling's big top burn to the ground wanted nothing to do with the show returning to the state, others were interested in revisiting the circus, including Plainville resident Patty Murphy, now almost nine years old. Miss Murphy was seriously burned in the Hartford circus fire, and her parents and little brother were killed; she attended one of the Friday performances at Tinty's Ranch with her aunt and uncle and was said to have enjoyed the show.

Added safety measures were in place for the circus for this tour through Connecticut. Steel chairs bolted to steel platforms replaced the flammable, unsecured painted-wood seats that proved to be a fatal obstacle for many at the Hartford fire on July 6, 1944. The animal runways that prevented dozens from reaching the exits on that fatal day were replaced by portable cages that transported the animals to and from the performance rings, and local and state firemen and officials were on scene during set-up, tear-down and both performances, armed with hose lines run from nearby Hamlin's pond

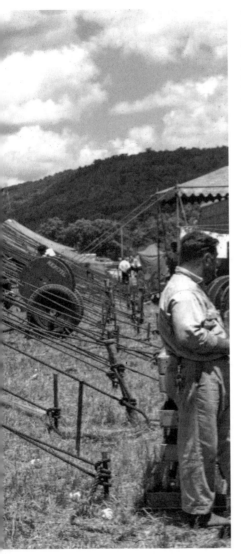

When the Ringling Brothers and Barnum & Bailey Circus returned to Connecticut, it installed fire escape steps from the top rows of seats to the outside of the big top, as shown in this 1949 photo taken before the circus's performance in Plainville, Connecticut. *Photo by Sverre O. Braathen, used with permission from Illinois State University's Special Collections, Milner Library.*

to provide an immediate and abundant supply of water in case of emergency. Atop each aisle in the grandstand sections were steel stairways that allowed patrons to quickly exit the tent without having to pass through the arena area. Nobody dared to smoke in the big top, heeding the posted signs and the ringmaster's announcement before the show.

Ringling's return to the city of Hartford was not until 1975, after the city's Civic Center construction was complete and an indoor facility capable of handling the Greatest Show on Earth was available. Since retiring its big top after the 1956 season, the circus was now showing exclusively in arenas equipped with seating. Ticket sales were brisk, and crowds were hearty for the week of shows that Ringling put on for circus fans in Hartford, despite the Shriner's Circus showing at the State Armory less than two weeks earlier.

In May 1950, Commissioner Hickey was made aware of a young man being held by Ohio authorities, Robert Dale Segee, accused of setting some fires in Circleville, Ohio. During initial questioning, Segee had admitted involvement in numerous crimes and fires throughout New England, including the Hartford circus fire. Hickey assigned detectives from Connecticut, Captains Paul Lavin and Paul Beckwith, to investigate. Within two weeks of confirming the reports, Lavin and Beckwith were in Ohio to meet with Ohio investigators with intentions of interviewing

Segee regarding his knowledge of the circus fire. Segee had told Ohio investigators that a red man came to him in a dream and told him to start fires and that he saw the red man before the Hartford circus fire. His next recollection was waking up in a tent after the fire. Segee recalled seeing the red man strike a match and igniting the sidewall of the tent, and he thought that what he saw might have been himself starting the fire. While Ohio authorities were cordial to the Connecticut detectives, it became apparent that fire marshal Harry J. Callan and deputy fire marshal R. Russell Smith were conducting their own investigation into Segee and his involvement in several Ohio fires, some in Maine and New Hampshire and the Hartford circus fire.

Lavin and Beckwith were denied access to Segee, with Smith explaining that a psychiatric evaluation was ordered for Segee and the doctor had requested that the subject not be interviewed or agitated while he waited for his hospital stay. While Segee was kept under review at Lima State Hospital over the next few months, Lavin and Beckwith began investigating the crimes in Maine and New Hampshire that Segee had confessed to Ohio authorities. During their investigation, they crossed paths with deputy fire marshal Smith from Ohio, also investigating Segee's crimes. Hickey and Ohio fire marshal Callan had harsh words over Smith's investigation and Callan's sharing information with the press and not including Connecticut in the investigation into the Hartford fire; Hickey was instructing his men to not involve the press in the investigation, yet Callan was feeding information to the press regularly, including *Life* magazine for a July 1950 story. Callan let Hickey know that he'd share the results of their investigation with him when their report was complete.

Segee's background and the crimes he confessed to were investigated by Connecticut and Ohio detectives, with full cooperation from the Maine and New Hampshire authorities. Segee appeared to have had a rough childhood in the Portland, Maine area, having moved from house to house with his family and endured abuse from his father and brothers. The entire family, including Robert, was considered undesirable by acquaintances who were interviewed. After school let out in June 1944, Segee was working for his father's house-wrecking business in Portland and had a fight with his brothers. The fourteen-year-old Segee ran away and joined the circus; Ringling was in town, and he found work with the show. Those who knew him remember Robert coming back a couple weeks later with burns on his hand and boasting to everyone of

his adventures; how he helped rescue people from the fire, how he beat up a man who was stealing from the dead and how he had relations with one of the circus executive's daughters. Segee's friends and family knew he had a wild imagination and told many unbelievable tales and that he often complained of dreams and hallucinations.

Lima State Hospital released Segee from its care in October 1950, with doctors declaring him to be poorly educated and below normal intelligence—sane but neurotic and compulsive. Their studies indicated that Segee was punished as a child by his father with fire, and he would abuse fire after dissatisfying sexual situations. Segee had both admitted and denied involvement in the fires for which he was accused, including the Hartford circus fire, and his doctors were inclined to believe that even if he did not commit the crimes, he was capable of them and potentially dangerous. He pleaded guilty to the Circleville fires and was sentenced to four to forty years at Mansfield Reformatory in Ohio. He spent much of his next forty years in and out of prison and mental hospitals. Commissioner Hickey declared, after his review of the Ohio investigation report and the reports of his own detectives, that there was no evidence that warranted an arrest of Segee for involvement in the Hartford circus fire and that if Segee had in fact set the fire, they would not be able to prosecute him since he was fourteen years old at the time and considered a minor in Connecticut.

In March 1991, Connecticut's Department of Public Safety commissioner ordered the origin and cause of the Hartford circus fire to be reexamined based on findings brought to the department's attention by Lieutenant Rick Davey of the Hartford Fire Marshal's office. Davey had studied files and photos at the State Archives and had concluded that the fire was arson started by Robert Segee. He had also concluded that the unidentified body of Little Miss 1565 was Eleanor Cook, and his findings prompted the state medical examiner's office to issue a corrected death certificate. Davey's work was to be collected in a book that he was writing, and he was very interested in participating in the investigation. Detective William T. Lewis was in charge, and the detectives were advised that this case should not take precedence over any current, active investigation.

Two years later, in March 1993, the investigators had pored over all available documents, photographs and evidence available to them and arranged an interview with the aged, poverty-stricken Robert Segee at the home he shared with his daughter's family in Columbus, Ohio. Captain Lewis and Sergeant Paul Butterworth, commander of the Bureau of

Investigations and Enforcement in the state fire marshal's office, journeyed to Ohio, after Butterworth denied Davey's request to attend and participate. Segee was very talkative and friendly with the detectives in the recorded interviews, and almost fifty years after the event, his recollection of July 6, 1944, during the two-day interview was that he had finished his work setting spotlights for the show and went to a theater in Hartford to see a movie. On the bus ride back to the circus grounds, people were talking about the big top being on fire, and by the time he returned, everything had burned to the ground. His confession to Ohio police in 1950 had been coerced out of him during a vigorous interrogation, and he felt like the Ohio investigators and doctors had brainwashed him. Segee felt that they did not like him because of his American Indian heritage.

On the second day of interviews, Segee admitted that he struggled to separate his two realities; one as a white man and one as Chief Black Raven, a shaman, and that he wanted to make peace with the spirit Wonka Tonka. Telling the truth would bring him peace, and he insisted repeatedly during the interviews that he did not start the circus fire. He felt like a failure that day for leaving the grounds and not being there to help. Segee told them there were many disgruntled circus employees who hadn't been paid, and someone might have started the fire with a magnifying glass. It was apparent that the prime time to interview Segee as a suspect in the circus fire had long passed; Detective Lewis and Sergeant Butterworth didn't feel that they gained any additional, useful information about the cause and origin of the fire, and they didn't believe there was sufficient evidence to bring any charges against Segee.

The investigators continued with their work, and having reviewed old, conflicting reports on the possibility of a cigarette igniting grass, they looked to forensic scientist Dr. Henry Lee of Connecticut's State Forensic Lab to review the case and provide his opinion. Dr. Lee and his forensic team conducted numerous tests of burning cigarettes in various types of grass, indoor and outdoor, and determined that a cigarette alone would not set the grass on fire. Charring and smoke were produced, but ignition was not achieved. Lee's conclusion was that a cigarette did not start the grass on fire, as Commissioner Hickey had concluded in his 1945 report, but if other combustibles were present in the men's toilet enclosure, the conditions would have been different. He believed the fire was accidental and not likely arson.

Lacking solid evidence, the reinvestigation case was officially closed in June 1993. The investigative team's conclusion was that the origin of the fire

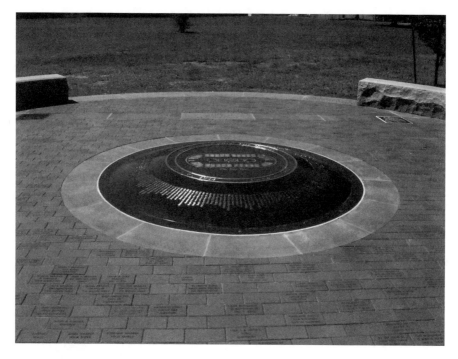

The bronze memorial medallion at the Hartford Circus Fire Memorial is embossed with the names of each of the victims of the circus fire. Contributors were allowed to purchase personalized bricks, which surround the medallion, located on what was once the center ring of the big top. *Photo by author.*

was inside or just outside the men's toilet enclosure, between the enclosure and the big top. A carelessly discarded cigarette tossed into the grass at the base of the sidewall or supports was ruled out, and it would be impossible to rule out all possible accidental causes. There was no indication of arson, and Robert Segee had denied involvement; the cause of the fire was listed as "undetermined."

The Hartford Circus Fire Memorial Foundation completed construction of a memorial at the site of the circus fire on July 5, 2005, sixty-one years after the fire. The Fred D. Wish Elementary School now stands on the site, and the dogwood trees in the field behind the school outline the perimeter of the big top where it burned to the ground in 1944. The progress of the fire is described on bronze plaques that line a path leading to a bronze medallion, embossed with names of those who died in the tragedy. Marking the exact location of the center ring of Ringling's big top, the giant medallion is surrounded by memorial stones with messages from

supporters of the project. Eleven years earlier, on the fiftieth anniversary of the fire, then captain Charles Teale and the Hartford Fire Department presented a plaque to the principal of the school for display in the lobby. The plaque was inscribed, "In loving memory of those who perished on this location fifty years ago, July 6, 1944, and with heartfelt condolences to their survivors."

SELECTED BIBLIOGRAPHY

Facts, names, dates and background information were collected from and confirmed with multiple sources whenever possible. Following is list of the most useful of the sources.

Bradbury, Joseph T. "The Season of 1944, Ringling Bros. and Barnum & Bailey Circus." *White Tops* (May/June 1981 and July/August 1981).

Hartford County Superior Court. *State of Connecticut v. Ringling Bros. Barnum & Bailey Combined Shows, Inc., et al.* Supporting statement and data on motion for suspension of sentences and for leave to withdraw pleas of nolo contendere. Hartford, CT, 1945.

Hickey, Edward J. *Report of the Commissioner of State Police as State Fire Marshal to State's Attorney for Hartford County Concerning the Fire in Hartford on July 6, 1944, at the Ringling Bros.–Barnum and Bailey Combined Shows, Inc.* Hartford, CT, 1945.

Kelly, Emmett, with F. Beverly Kelley. *Clown.* New York: Prentice-Hall, Inc., 1954.

Kimball, Warren Y. "Hartford Circus Holocaust." *National Fire Protection Association* 38, no. 1 (July 1944).

Municipal Board of Inquiry. *Report of the Municipal Board of Inquiry on the Circus Disaster.* Hartford, CT, 1944.

Office of the Public Records Administrator and State Archives. *Subject Guide to the Hartford Circus Fire, July 6, 1944.* 2nd ed. Hartford, CT: State Library, 2002.

Ringling Bros and Barnum & Bailey. *Ringling Bros and Barnum & Bailey Circus Magazine.* With program. USA: Harry S. Dube, 1944.

———. *Ringling Bros and Barnum & Bailey Circus 1944 Route Book: Route, Personnel and Statistics for the Season of 1944.* Sarasota, FL: J.C. Johnson, 1944.

CONNECTICUT STATE LIBRARY RECORDS

Access to the *Hartford Courant* newspaper archives was made possible by the Connecticut State Library.

Record Group 003. Records of the Judicial Department, which includes Arbitration Agreements, Hartford Circus Fire Settlement, Hartford County, Superior Court; Claimant Files, Hartford Circus Fire Settlement, Hartford County, Superior Court; Criminal Files, Hartford County, Superior Court; Hartford County Coroner Records, Inquest Testimony, Findings and Transcripts; Medical Examiner's Report, Hartford County Coroner Records.

Record Group 050. Records of the State War Council.

Record Group 069. Manuscripts Collection, which includes E.S. Rogin's Receivership Files; Arthur D. Weinstein Collection, lawsuits arising from the circus fire; Dr. Milton Fleisch Collection, chief resident at Municipal Hospital at the time of the circus fire.

Record Group 161. Records of the Department of Public Safety, which includes Division of State Police, Investigation Files, Hartford Circus Fire.

MORE RECOMMENDED READING

Cohn, Henry S., and David Bollier. *The Great Hartford Circus Fire: Creative Settlement of Mass Disasters.* New Haven: Yale University Press, 1991.

Massey, Don, and Rick Davey. *A Matter of Degree: The Hartford Circus Fire and the Mystery of Little Miss 1565.* Simsbury, CT: Willow Brook Press, 2001.

O'Nan, Stewart. *The Circus Fire.* New York: Doubleday, 2000.

INDEX

ABOUT THE AUTHOR

Author Michael R. Skidgell was born in Hartford twenty-two years after the Hartford circus fire and has lived in Connecticut ever since, currently residing in Plainville with his son and their dogs and cats. Mike has been researching the circus fire since 2001, collecting items and information about the tragedy and sharing it all on his website, www.circusfire1944.com, including in-depth biographies of each victim and a vast collection of images.

Visit us at
www.historypress.net
...

This title is also available as an e-book